IMAGES
of America

MOUNT SHASTA

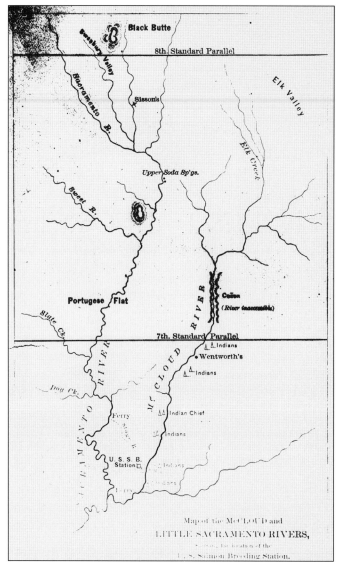

The Map of the McCloud and Little Sacramento Rivers was probably made by Livingston Stone, who operated the U.S. Salmon Breeding Station at Baird in 1875. Mount Shasta sits east of Black Butte, near the top of the map, but is not shown. South of Black Butte is the valley where the city of Mount Shasta is located. First called Wei-Nune-Char-Row (Northwest Valley) by Native Americans, it was known by early settlers as Bear Valley and later Strawberry Valley. Swanbury Valley's origin is unknown. "Sisson's" refers to an important landmark, the famous inn operated by Justin H. Sisson, who later became the founder of the town of Sisson. The name was officially changed to Mount Shasta in 1924. (Courtesy Siskiyou County Museum.)

ON THE COVER: A good old-fashioned Fourth of July parade is a tradition that dates back to the early days of Sisson. This photograph of the brass band and floats was taken by Charles Richard Miller, known as C. R. Miller, around the early 1900s on a road leading out of Sisson, looking east toward the town and Mount Shasta. Miller became a well-known photographer of the region specializing in scenes of logging activities. (Courtesy Sisson Museum.)

IMAGES
of America

MOUNT SHASTA

Darla Greb Mazariegos

ARCADIA
PUBLISHING

Published by Arcadia Publishing
Charleston SC, Chicago IL, Portsmouth NH, San Francisco CA

Printed in the United States of America

Library of Congress Catalog Card Number: 2007929238

For all general information contact Arcadia Publishing at:
Telephone 843-853-2070
Fax 843-853-0044
E-mail sales@arcadiapublishing.com
For customer service and orders:
Toll-Free 1-888-313-2665

Visit us on the Internet at www.arcadiapublishing.com

To Carmen, Hannah, and Nolan

CONTENTS

ACKNOWLEDGMENTS

This book would not have been possible without the support of a large number of people and organizations. First, I am deeply grateful to Dennis Freeman, director of the College of the Siskiyous Library in Weed, California, who was a major source of research materials, images, and enthusiasm for the project. The book would not have been possible without his invaluable support. The library's Mount Shasta Collection is the source of many of the images, and I am honored to be able to highlight this collection. I also want to sincerely thank college library assistant Marcia Eblen, who scanned the photographs and whose expertise and efficiency made this part of the project run so smoothly.

The rest of the images came from a number of public and individual collections. I want to thank Michael Hendryx, director of the Siskiyou County Museum, for giving me access to their museum's extensive photographic collection and to museum assistant Richard Terwilliger; Sisson Museum executive director Wanda Welbourne for use of their photographs and for her and the museum board's interest in supporting the project; William A. Jones, director of the California State University, Chico, Meriam Library, Special Collections, for access to the wonderful Edward Stuhl Collection; Julie Cassidy of the Mount Shasta Ranger Station for use of their forestry photographs; William Miesse for providing his images and for authoring the monumental *Mount Shasta, An Annotated Bibliography*; historian Donna Kohn Brooks for her contribution to the Siskiyou Pioneer Mount Shasta edition, "the" resource for local history of the town; and Perry Sims, early Sisson expert, for use of his photographs and for reviewing my chapters on early Sisson history. The book would also have not been possible without the generous support of the Jefferson Economic Development Institute of Mount Shasta.

I want to express my appreciation to Devon Weston at Arcadia Publishing, whose positive energy and enthusiasm helped keep me inspired. Finally I want to thank my family—my husband, Roberto Mazariegos, for supporting me throughout the long months of research and writing; my parents, Gordon and Darlene Greb, for surrounding me with history as a child; and my three children for listening to my stories! I would also like to recognize Dr. Robert Jackson, whose words of encouragement long ago helped give me the courage to take on this project.

INTRODUCTION

Since its first sighting by fur trappers more than 180 years ago, Mount Shasta has fascinated travelers of all kinds. A dormant volcano located in Siskiyou County, California, it soars to an altitude of 14,162 feet, the fourth highest volcano in North America. Its physical characteristics have inspired mountaineers, scientists, geographers, and naturalists to investigate it, while its natural beauty acts as a creative force for artists, writers, and spiritualists. On its southwestern flank, the small town of Mount Shasta lies 10,000 feet below the summit, dominated by the presence of this "Monarch of Mountains."

For approximately 9,000 years, Native Americans made the greater Mount Shasta region their home. The mountain's remote location in far Northern California, surrounded by high mountain ranges and rugged terrain, made it a difficult area to explore. It was not until in the late 1820s that European and American fur brigades and exploring parties traveled through the area. With them were artists and naturalists who produced the first images of Mount Shasta and its people, a fleeting glimpse of a way of life soon to disappear. By the 1850s, miners and settlers were passing by Mount Shasta along the California-Oregon Trail. It was at this time that writer Joaquin Miller arrived. His experiences, including his time living with the McCloud River Wintu, had a large influence on his later writings, in which Mount Shasta played a central role.

One of the few legacies left to the area's first inhabitants is the name—Mount Shasta—the only major mountain in the West whose name is of Native American origin. "Shasta" is most likely derived from the word *Sastise*, which the Klamath Indians near the California-Oregon border used for their enemies living to the west and south. In December 1826, fur trapper Peter Skene Ogden documented the sighting of what was probably present-day Mount Shasta, although he did not give it a name. In February 1827, Ogden gave the name "Sastise" or "Sasty" to present-day Mount McLoughlin in Southern Oregon, not to present-day Mount Shasta. Depending on which map was consulted, Mount Shasta was recorded as Mount Simpson, Mount Jackson, or Pit Mountain. Explorers began confusing which mountain was Sasty, and in 1841, the Wilkes Expedition made an error on its map, using Shaste for present-day Mount Shasta, the major reason for the transfer of the name. The mountain's name was officially spelled "Shasta" in about 1850 when Shasta County and its county seat, the city of Shasta (near Redding), were established.

Soon after gold was discovered, settlers began staking claims to land in what became known as Strawberry Valley. One of these early settlers was Justin H. Sisson, who opened a small inn called Sisson's, where he offered a guide service, outfitted mountaineers, and organized hunting and fishing parties. When the post office was established in Strawberry Valley in 1870, the settlement was named Berryvale. Sisson's fishing resort on the McCloud River was also a popular destination for visitors. One of Sisson's guests was John Muir, who visited Mount Shasta about 14 times and climbed the mountain three times during his lifetime. Muir later advocated preserving the mountain as a national park after witnessing the forest's destruction by lumber companies on the slopes of Mount Shasta.

In the early 1880s, the Central Pacific Railroad made an agreement with Justin Sisson to establish a town on his land and name it "Sisson." In 1886, with the railroad construction completed, the

mountain's great forests became readily accessible to the lumber industry. Numerous box factories, shingle mills, and sawmills were built, spurring the development of Sisson. Hotels, restaurants, and saloons were opened to serve both the lumbermen and tourists. During its early history, the downtown business district and other landmarks were ravaged by numerous fires, the first occurring in 1896.

After 1887, the Southern Pacific Railroad promoted its new Shasta Route as having the finest scenery on the "Road of a Thousand Wonders" with Mount Shasta as its star attraction. Health resorts were developed near the soda and mineral springs produced by Mount Shasta, where travelers came to stay for weeks or months. Some visitors discovered Mount Shasta's beauty and purchased property, where they built summer homes and estates.

In December 1889, Mabel Hubbard Bell, wife of Alexander Graham Bell, traveled by train from Ashland to San Francisco. On the trip, she composed a letter to her husband expressing the excitement and anticipation she felt at seeing Mount Shasta for the first time:

> I have seen Shasta at last, and I was first of all in the car to see it . . . like some mirage pictured high on the deep blue sky of early evening. . . . All day long we have been watching and waiting for it, rejoicing in the hopes called forth by the bright morning, and growing more and more disappointed as the hours crept on. . . . Then the clouds gradually swept away and there was the clear blue sky. . . . There it burst suddenly on my view in all it's glorious majesty, gleaming white and pure and defined with razor-like sharpness against the blue evening sky with not a cloud and not another mountain to mar its glory. Talk of Mt. Blanc, it is nothing in comparison.

Change came to Mount Shasta again with a new mode of transportation, the automobile. With the construction of the Pacific Highway in the early 1900s, the automobile brought more visitors to the region, initiating the decline of the railroad resorts. Auto camps and small motels became the new form of lodging. Another change came in 1924 when Sisson was officially renamed "Mount Shasta." With the change, the city gained a closer association with the mountain, but it also lost its historical link with its founder Justin H. Sisson. Nevertheless, Sisson is still remembered with such places as Sisson School, Sisson Street, Sisson Museum, and Sisson Meadows.

Both Mount Shastas—the mountain and the city—continue to serve as unique destinations, offering many attractions to a wide variety of people and interests. Outdoor enthusiasts can still enjoy mountaineering, camping, hiking, fishing, and skiing. Although John Muir's plea to designate Mount Shasta as a national park was not realized, a national forest was established by Pres. Theodore Roosevelt in 1905, and in 1984, the Mount Shasta Wilderness was created. Mount Shasta is also the center for a variety of spiritual movements whose beliefs, legends, and stories have created a distinct cultural identity. Finally, the mountain continues to offer its natural resources to the next generation of entrepreneurs who have discovered that the mountain's "gold" is its pure cold waters. The water bottling industry has replaced the lumber mills of yesterday.

Today the city of Mount Shasta offers a small-town atmosphere with restaurants, cafés, bookshops, and clothing boutiques along with shops that feature crystals and other spiritual items. The fires that played an early role in Sisson's history have been kept at bay in the new Mount Shasta. However, high above the city, the mountain of Mount Shasta presides, an ever-present sentinel reminding us that the natural world and all it bestows are never far away.

One

SHADOWS OF SHASTA

One of the earliest descriptions of Native Americans who lived near Mount Shasta was written by artist/naturalist Titian Ramsey Peale from the United States Exploring Expedition, also known as the Wilkes Expedition, of 1838–1842. "They were dressed in deer skins with the hair, belted round the waist with an ornamentive hide belt, and 'raw hide' mochasins—hair long and without ornament." The mother and baby pictured here were the Shasta Indians, which is divided into three major groups in California: the Shasta Valley, the Scott Valley, and the Klamath River Shasta. A small branch of the Shasta, the Okwanuchu, occupied the territory southwest of Mount Shasta, which included the headwaters of the Sacramento and McCloud Rivers. By the 1915 census, the Okwanuchu had virtually disappeared, and the Wintu had moved farther north to territory formerly occupied by the Okwanuchu and were found living in Sisson and Dunsmuir by this time. (Courtesy Siskiyou County Museum.)

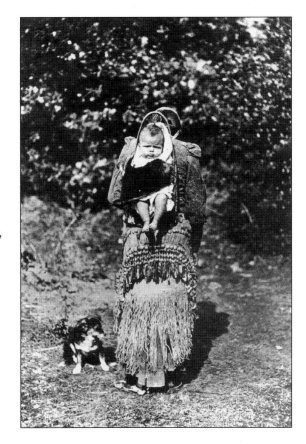

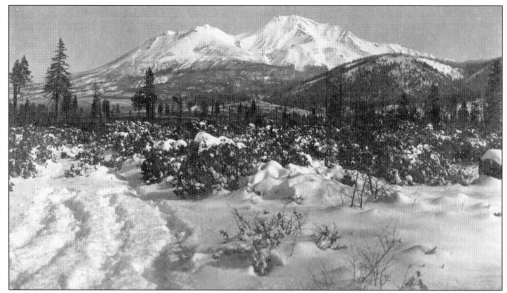

Visible for more than 100 miles, Mount Shasta is the second highest peak in the Cascade Range and the fifth highest mountain in California. It is considered to be one of the world's great strato volcanoes, created over time by layers of alternating ash and lava flows. The southwest side (above) and northeast side (below) of Mount Shasta are pictured; the highest peak of Shasta rises to an elevation of 14,162 feet, while Shastina reaches 12,330 feet. Geologist Clarence King wrote in 1870: "If I ask myself to-day what were the sensations on Shasta, they render themselves into three—geography, shadows, and uplifted isolation." (Both courtesy College of the Siskiyous Library.)

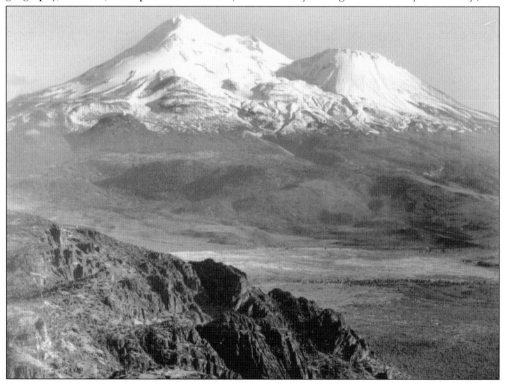

"Lonely as God, and white as a winter moon, Mount Shasta starts up sudden and solitary from the heart of the great black forests of Northern California," wrote writer Joaquin Miller in *Life Amongst the Modocs*. The mountain appears as one solitary volcanic cone in these two views: the west side taken from Edgewood in 1894 (above) and the southeast from near McCloud (below). The Shasta Indians named the mountain Wy-e-kah meaning "Great Spirit"; while the Wintu to the south knew it as Bo-lem-poi'-yo, meaning "Big Mountain." Mount Shasta's evocative presence has produced a unique spiritual culture, from the early Native American legends that describe the mountain's creation to folklores and spiritual movements that developed after the arrival of the white man. (Above, photograph by Raper J. Waters; both courtesy College of the Siskiyous Library.)

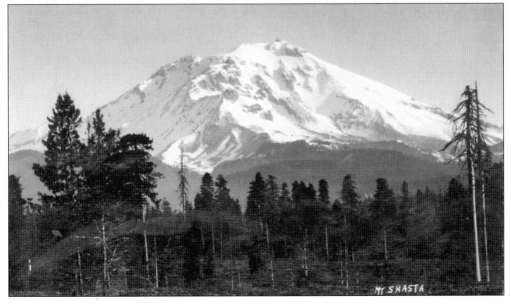

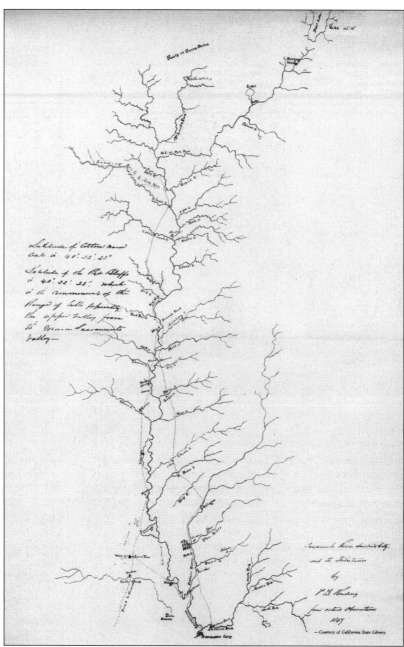

The map of the "Sacramento Rivers above Sact'o City and its Tributaries" was made in 1849 by California pioneer Pierson B. Reading. In this map, Reading has used the name "Sasty or Snowy Butes" for Mount Shasta. One who also knew it as Sasty was fur trapper Alexander R. McLeod. In January 1830, he and his brigade were caught in a snowstorm southeast of Mount Shasta. His camp is shown near the top center of the map. After his horses died, he was forced to cache his furs and return to Fort Vancouver on foot empty-handed, his highly valued pelts, about 2,400, never being recovered. Historians have shown that the origin of the name of the McCloud River came from "McLeod," which is pronounced the same as McCloud, but it has also been attributed to Ross McCloud, one of Mount Shasta's early pioneers. (Courtesy College of the Siskiyous Library.)

12

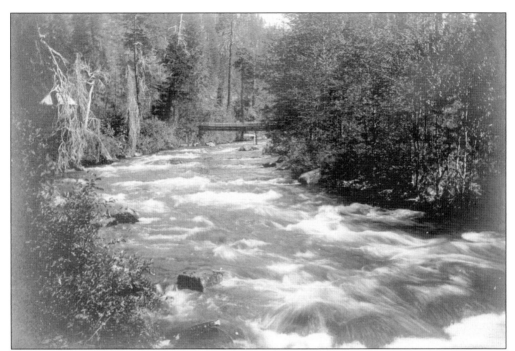

A trail following the Sacramento River (above) was first used by Native Americans, then by fur trappers who knew it as the La Framboise Trail for Michel La Framboise, a Hudson Bay Company fur brigade leader who made annual treks from the Columbia River to the San Joaquin Delta in the 1830s. The trail was later known as the Siskiyou Trail and California-Oregon Trail. Stephen Hall Meek, pictured at right, was one of the well-traveled fur trappers who, after years of adventure all over the west and abroad, made his final home in Siskiyou County. (Both courtesy College of the Siskiyous Library.)

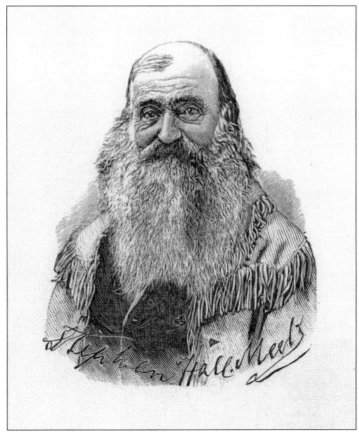

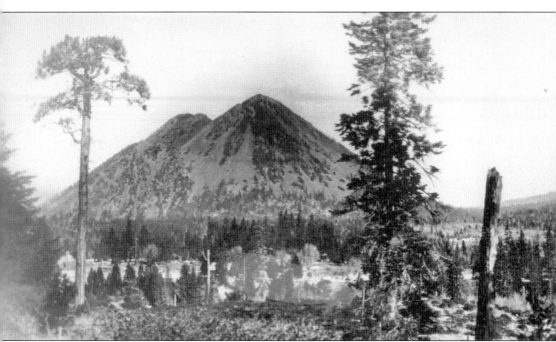

Black Butte (left) and Mount Shasta are shown in this panoramic view of Strawberry Valley. One of a series of plug domes, Black Butte reaches an altitude of 6,325 feet, still a high mountain if not compared to its monumental neighbor. The term *butte* is of French origin meaning "ridge" and was used by early trappers, many of whom were French. The Native Americans called it

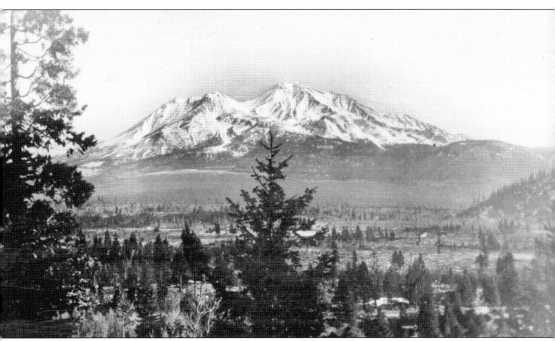

Saw-chem poyok, meaning "beaver mountain." When eminent geologist James D. Dana of the U.S. Exploring Expedition described Black Butte in 1841, he wrote that its "sides were enveloped in pines or cedars, except about the summit, where only a few stinted trees made out to grow." (Courtesy College of the Siskiyous Library.)

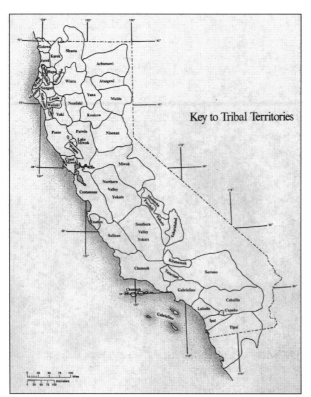

The Key to Tribal Territories shows the groups that lived in the territory of Mount Shasta in far northern California: the Shasta (and Okwanuchu), the Wintu, and the Ajumawi/ Atsugewi. Mount Shasta is located near where these groups intersect. The Modoc's territory (not shown) was northeast of the mountain. (Courtesy College of the Siskiyous Library.)

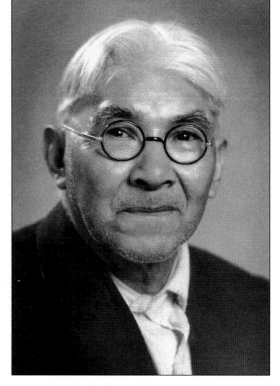

In the 1850s, a group of Wintu fled their ancestral home in the Trinity River Valley, after it became overrun by gold miners, to live at Upper Soda Springs or Mem-okis-takki—"strong water place." Laktcharas Tau-hin-dauli (Grant Towendollay), pictured here, was born there in 1873. His father, Wi-tau-hin-dauli, worked for the McCloud family who owned the springs and was a Wintu chief and shaman. His son became the last chief of the Trinity River Wintu. (Courtesy Siskiyou County Museum.)

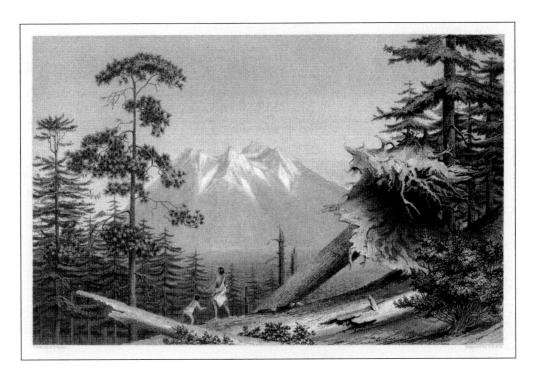

Shaste Peak (above) by artist Alfred T. Agate is the first known visual of Mount Shasta completed during the U.S. Exploring Expedition of 1838–1842, which included top scientists and naturalists who traveled throughout the world by ship to conduct scientific studies. In October 1841, Lt. George Foster Emmons led a group south on foot from the Columbia River to Mount Shasta. Reaching the headwaters of "*rio* Sacramento," they set up camp. Naturalist/artist Titian Ramsey Peale wrote, "The summit of Mount Tshasty presented a beautiful view from our camp when its snow was illuminated by the pink rays of the setting sun." Agate also drew *Shaste Hut* (below), published in Peale's journal. Formed by willow poles, the huts were covered with pine bark and animal skins and probably used by individual families as sweathouses. (Above, courtesy College of the Siskiyous Library; below, courtesy William Miesse.)

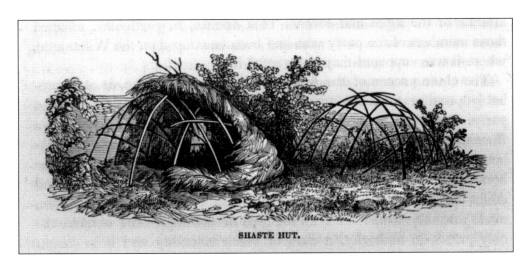

SHASTE HUT.

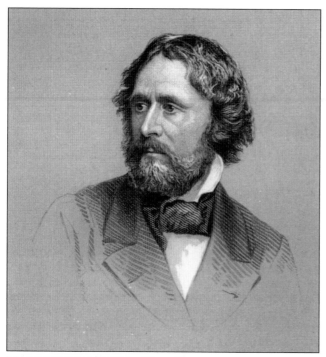

In 1846, John C. Fremont, pictured at left, began his third expedition to California with a group of 60 men from his camp, near present-day Red Bluff, to Klamath Lake via the Pit River. This painting entitled *Forest Camp Shastl Peak* (below) was made by Edward Kern as they passed to the east of Mount Shasta and appeared in Fremont's journal. Unlike the Wilkes Expedition, Fremont's trip was not without incident along the route. Attacks were made on the Native Americans near present-day Red Bluff, and battles occurred with the Klamaths. (Both courtesy College of the Siskiyou Library.)

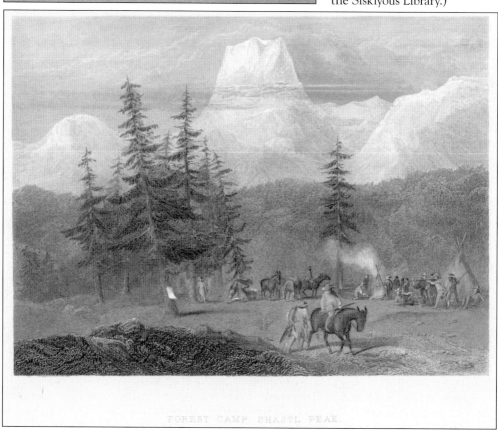

FOREST CAMP SHASTL PEAK.

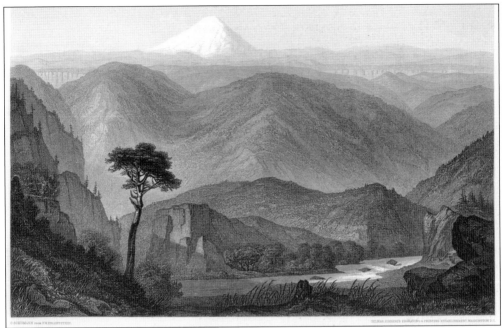

Baron von Egloffstein made this engraving titled *Portion of Main Mountain Passage of the Upper Sacramento or Pitt River, July 20 at 1 p.m., 25 Miles South of Mt. Shasta* in July 1855 during the 41st parallel railroad survey, led by Lt. James Beckwith. The artist is recognized as having drawn the most detailed illustrations of any artist of the railroad surveys. (Courtesy College of the Siskiyous Library.)

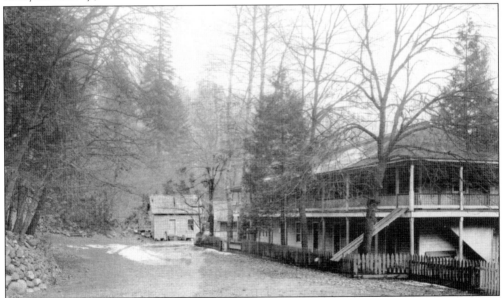

In 1855, Ross McCloud surveyed and completed a new mountain trail from the mining town of Shasta (near Redding) through the Sacramento River Canyon, providing an alternate route to the longer Trinity Center and Pit River roads. That same year, he and his wife, Mary Campbell McCloud, purchased property at Upper Soda Springs and made improvements to an existing wayside inn. The Soda Springs Resort is pictured here. (Courtesy College of the Siskiyous Library.)

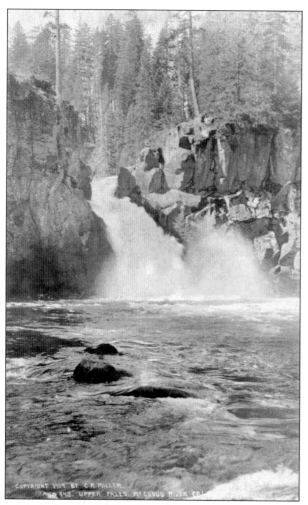

COPYRIGHT 1909 BY C.R. MILLER
343. UPPER FALLS, McCLOUD RIVER, CAL.

McCloud River, pictured at left in 1909 at Upper Falls, is poetically described by Joaquin Miller: "On the east side of Shasta, in the deep and somber gorge at its base, and in the shadow of its glacier-clad domes, flow the cold and crystal waters of the McCloud River, the source of which is found in the ice caverns of the 'Monarch of Mountains.' At the Falls which are upwards of a hundred feet in sheer descent, the great emerald pools swarm with salmon, unable to pass the great barrier. Here they fall easy victims to the unerring spear of the Indian." The etching of the Native American spear fishing for salmon on the McCloud River (below) was published in the July 21, 1888, *Harper's Weekly.* (Photograph by C. R. Miller; both courtesy College of the Siskiyous Library.)

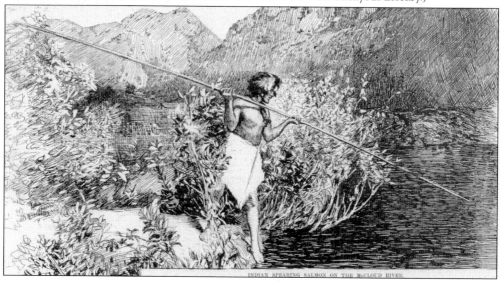

INDIAN SPEARING SALMON ON THE McCLOUD RIVER.

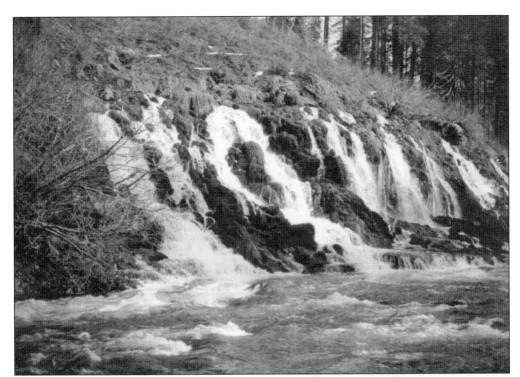

McCloud River's Big Springs are just one of the many springs produced by Mount Shasta. Originating from melting snow and glaciers high on the mountain, the water percolates into its porous rock and ash and reemerges at its base in the form of springs and waterfalls. (Photograph by Edward Stuhl; courtesy California State University, Chico, Meriam Library, Special Collections.)

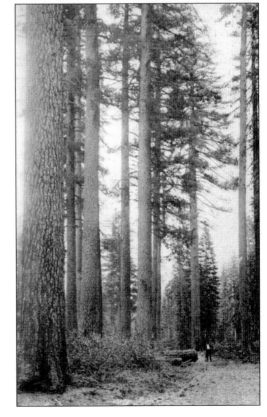

Douglas fir, yellow pine, sugar pine, and Shasta fir can be found on the slopes of Mount Shasta. This tall stand of sugar pine was located south of Mount Shasta in the McCloud Basin. Prior to the arrival of the lumber industry, an unbroken stretch of forest with a variety of trees once extended from Strawberry Valley over the summit to McCloud. (Courtesy College of the Siskiyous Library.)

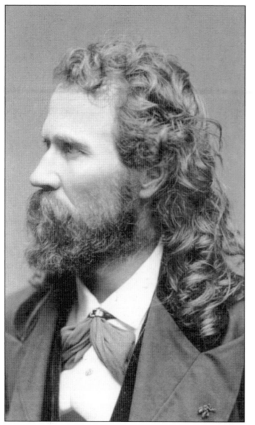

Joaquin Miller had the photograph at left taken for a visiting card in about 1875. Miller became a famous writer using Mount Shasta in many of his books, poems, and plays. His most famous work, *Life Amongst the Modocs*, published in 1873, is now recognized for its sensitive depiction of Native Americans, a radical position at that time. He also proposed creating an Indian Republic with Mount Shasta as its geographic center. The engraving below is of Squaw Valley from a painting by artist Thomas Hill published in John Muir's *Picturesque California* in 1888. Known in Wintu as Now-ow-wa, the valley is located between the Upper Sacramento and McCloud Rivers. A rare look into the world of the Wintu is given to us in Joaquin Miller's journal of 1856–1857, which he kept while living with them in Squaw Valley. (Left, courtesy College of the Siskiyous Library; below, courtesy William Miesse.)

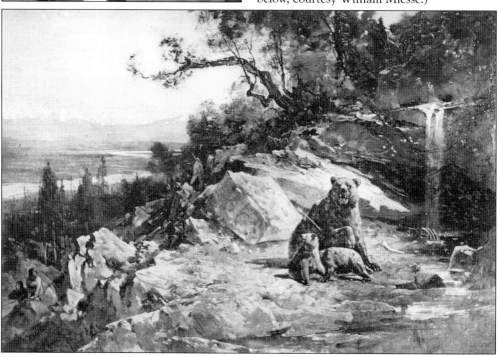

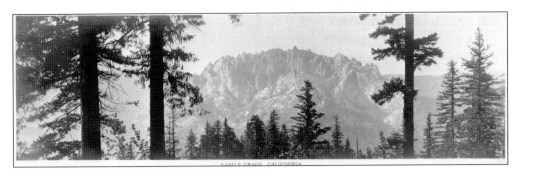

Castle Crags (above) is located southwest of Mount Shasta above the Sacramento River. Called Kukuparick meaning "Abode of the Devil" by Native Americans or "Castle del Diablo" by early settlers, it became the setting of Joaquin Miller's legendary story "The Battle of Castle Crags." In 1856, Miller was living with "Mountain Joe" (Joseph DeBlondy) in a cabin at Lower Soda Springs. While they were away, a group of Native Americans stole their food and supplies and burned down the cabin. Settlers, miners, and other Native Americans were recruited to search them out, and a battle ensued in the crags. Two of the Modocs that were killed were thrown into Castle Lake (below). Miller was injured by an arrow piercing his face and neck. (Above, courtesy College of the Siskiyous Library; below, photograph by John Oltman, courtesy William Miesse.)

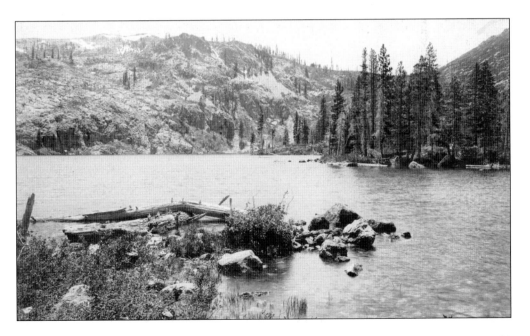

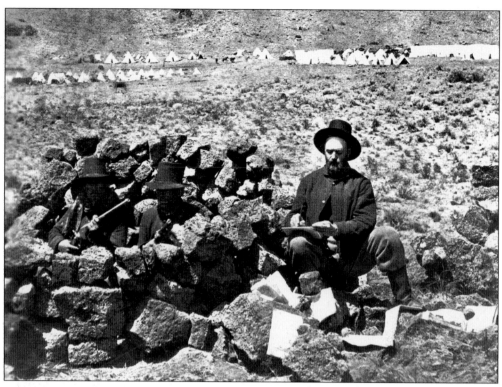

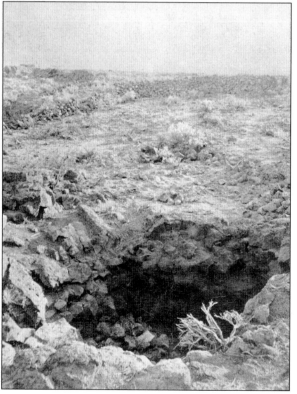

In 1872, the U.S. government ordered the Modocs, whose territory lay northeast of Mount Shasta, to move to a reservation where the Klamaths, their enemies, had been sent. Defying the government, some of the Modocs under the leadership of Kientpoos (Captain Jack) attempted to return to their ancestral lands. During the ensuing battles, 60 Modocs held off over 650 U.S. soldiers for nearly five months. Newspapers sent correspondents to report on the war (above). This cave in the lava beds (left) was the site of the Modocs' final stand until they ran out of supplies and were forced to surrender. Kientpoos and three leaders were hanged for the deaths of Gen. Edward Canby and Rev. Eleazar Thomas. The rest of the tribe was sent to a reservation in Oklahoma. It was at this time that Joaquin Miller's *Life Amongst the Modocs* was published. (Both courtesy Siskiyou County Museum.)

Two

STAGECOACH DAYS

One of the truly remarkable pioneers of the Mount Shasta area was Justin H. Sisson, founder of the city of Sisson (Mount Shasta). Upon his arrival in Strawberry Valley in the early 1850s, he first settled on Huckleberry Swamp. In the early 1860s, he purchased a house on Valley Road, expanding it into a popular inn called Sisson's. A college graduate and teacher prior to his arrival to California in 1850, his other talents were numerous: mountain guide, hunter, and angler, as well as businessman and real estate investor. His real estate holdings included 120 acres in Strawberry Valley, later to become the town of Sisson, and a fishing resort on the McCloud River (now part of the Hearst estate). Sisson's inn became a popular summer resort for well-known figures such as John Muir, California governor George Pardee, and artists Albert Bierstadt, Thomas Hill, and William Keith, who made the Mount Shasta area the subject of landscape paintings now highly valued. Thomas Hill's portrait of Sisson is on display at the Sisson Museum in Mount Shasta. (Courtesy Siskiyou County Museum.)

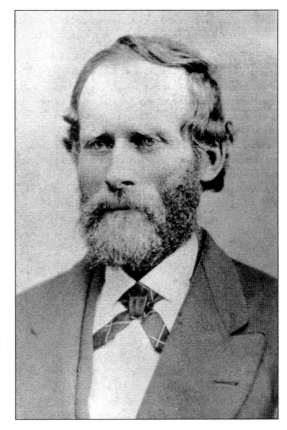

By 1858, a wagon road was being used heading north from Shasta, a mining town near Redding, to the Pit River ferry crossing. From there, saddle horses or pack mules, seen above, had to be taken through the Sacramento River Canyon to reach Upper Soda Springs. A stage line from Upper Soda Springs to Yreka had been started by William Sullaway (left) in 1857 on what was then called McCloud's Road (now Old Stage Road). In 1859, Willard P. Stone and the Stone Road Company began constructing a wagon road and 17 bridges from Upper Soda Springs to Shasta to replace the old pack trail. (Above, courtesy College of the Siskiyous Library; left, courtesy Siskiyou County Museum.)

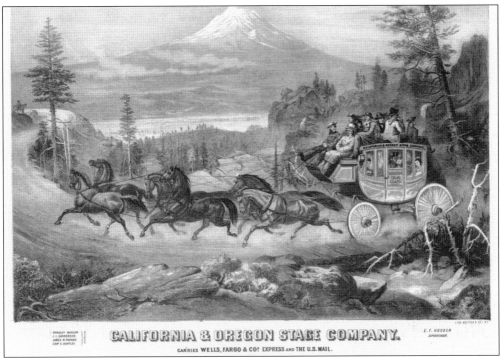

Britton and Rey published this 1872 illustration by Aaron Stein for the California and Oregon Stage Company. Different versions of this illustration had already been published as broadsides in 1853 and 1860. On July 29, 1874, the *Yreka Journal* reported: "We notice in town a splendid picture of Mount Shasta, taken from the vicinity of Sisson's. . . . It is a splendid view of Mount Shasta, and is gotten up by the stage company as a representation of a fine view on their route through Shasta Valley." (Courtesy College of the Siskiyous Library.)

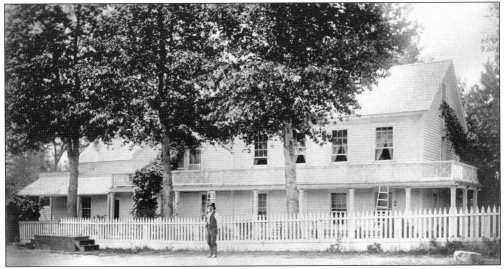

Justin Sisson is pictured standing in front of his hotel in August 1883. In 1870, the small settlement in Strawberry Valley was named Berryvale, and Sisson served as the first postmaster. Harry Babcock, son of San Francisco millionaire William F. Babcock, took this photograph on one of his trips to Mount Shasta. (Courtesy Siskiyou County Museum.)

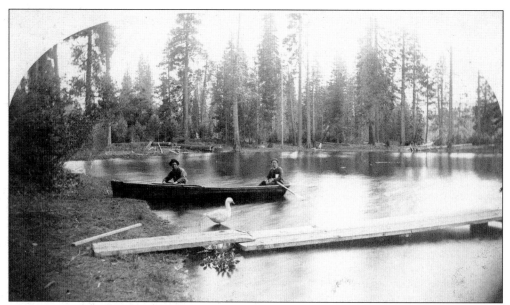

Justin Sisson expanded his hotel, adding rooms, orchards, a garden, croquet grounds, and a pond stocked with trout, pictured here with "Old Colonel" the duck in 1881 (with unidentified men). In 1876, Sisson wrote to A. L. Bancroft: "The season for Ladies and children is from June until Oct—The attractions of my place are the climate, scenery, the mineral waters, hunting and fishing. . . . Board for week from 10 to 12 dollars." (Photograph by Harry Babcock, courtesy Siskiyou County Museum.)

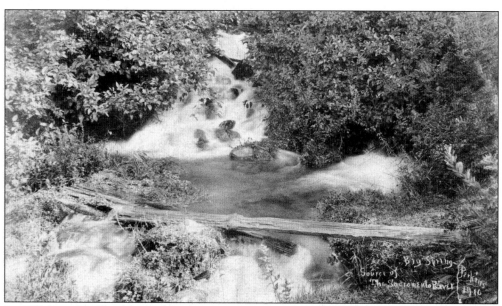

In 1859, Ross McCloud built the first sawmill in Strawberry Valley on Big Springs Creek. Big Springs later became part of Justin Sisson's property, located about a mile and a half from his hotel. John Muir described Big Springs, pictured in 1890, as being lined with emerald algae and moss and shaded by alder, willow, and thorn bushes, "in which give it a fine setting." (Photograph by Alfred J. Perkins, courtesy College of the Siskiyous Library.)

Lydia Field Sisson, Justin Sisson's wife, pictured at right, was known for her hospitality and the social gatherings she organized, including large Independence Day parties. In 1864, Fitz Hugh Ludlow and artist Albert Bierstadt traveled to Sisson on horseback. Ludlow wrote in an *Atlantic Monthly* article that they particularly enjoyed the fine meals prepared by Lydia Sisson and that they had "one of the most delightful weeks in our diary of travel through any land." (Courtesy Siskiyou County Museum.)

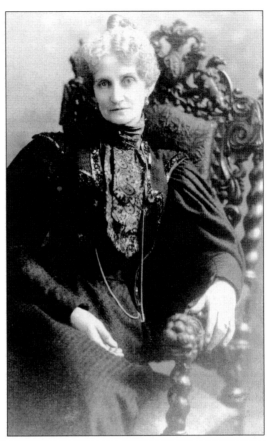

Guests at Sisson's enjoyed this lovely view of Mount Shasta. A tub and bucket factory was located across the road (center) and early settlers reported that the Wintu had a camp near by on Indian Lane. A tribute given after Sisson's death said, "Sisson's dealings with the Indians were characterized by the same honest generosity observed throughout his career and his sincerest mourners are among his Indian friends who had for years made 'Old Sisson' their summer home." (Photograph by Harold A. Parker, courtesy College of the Siskiyous Library.)

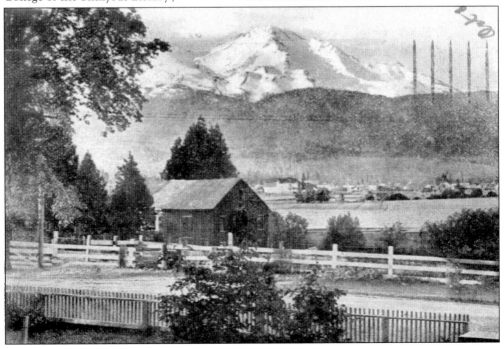

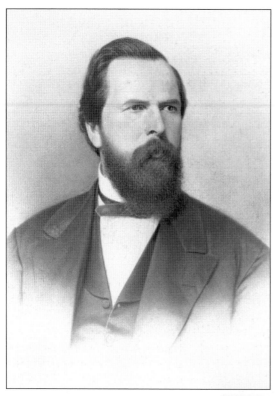

In September 1877, Gen. John Bidwell, pictured at left about 1861, recorded in his journal a trip that he and his wife, Annie, made to Mount Shasta. Among the group accompanying them were John Muir and botanists Sir Joseph Hooker and Dr. Asa Gray. Spending their first night at Sisson's, they traveled 15 miles up Mount Shasta where Sisson had set up a tent, dubbed "Camp Gray" in honor of "our worthy guest." The next day after failing to reach the summit, a few returned to Sisson's, the rest descending three miles to Bear Springs, pictured below. In 1890, Muir wrote to Bidwell: "And then how fine and how fruitful that trip to Shasta with you! Happy days, not to come again!" (Left, portrait donated by Bidwell Mansion State Park; below, photograph by Edward Stuhl; both courtesy California State University, Chico, Meriam Library, Special Collections.)

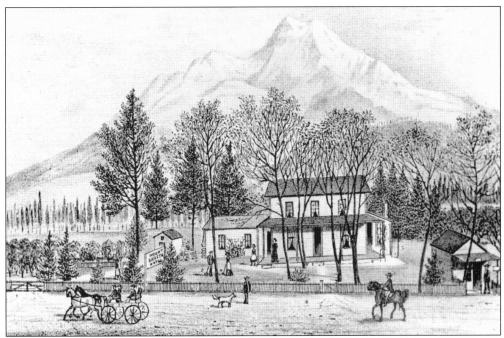

Across the stage road from Sisson's was another popular inn called the Mount Shasta Hotel, shown above, owned by Joseph and Sophia Fellows. The couple had purchased the property in 1866 and built a tub and bucket factory and the hotel, which also served as a stage station. One of the hotel's famous guests was Pres. Rutherford B. Hayes. After her husband died in 1872, Sophia or "Auntie Fellows," pictured below with her animals, continued to operate the hotel with the help of her brother Gilbert Lamphier. When the post office was relocated to the small store that she had opened, she served as postmaster from 1879 to 1887. The refurbished post office still remains on the property and is now a historic landmark. (Both courtesy Siskiyou County Museum.)

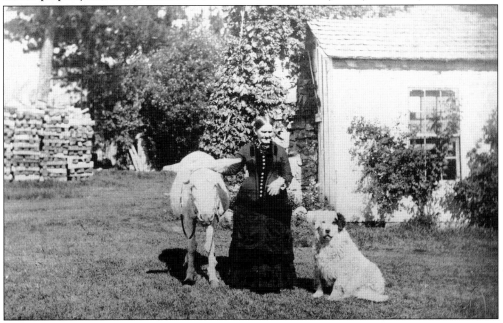

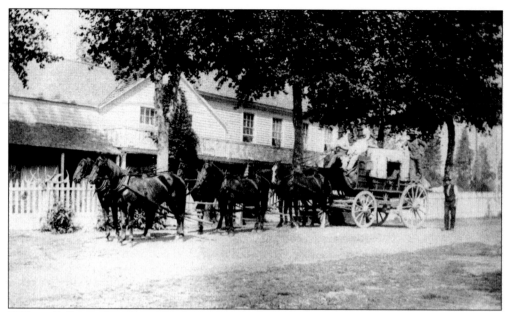

William Sullaway, founder of the area's first stage line, and his wife, Mary Parker Sullaway, were early settlers of Strawberry Valley. Their son John was one of the first stage drivers for the California and Oregon Stage Company; he is pictured above in the driver's seat in front of Sisson's in August 1883. The other men in the photograph are unidentified. The Sullaways owned 160 acres along the stage road in Strawberry Valley, which they had purchased from John King in 1858. Forest Home served as the area's first stop on the stage line and later a summer resort. Horse races were held on the road, and the family hosted many social gatherings. The Sullaway's daughter Mary is pictured below on a horse on the Sullaway property. The two people standing are unidentified but may be her parents. (Both courtesy Siskiyou County Museum.)

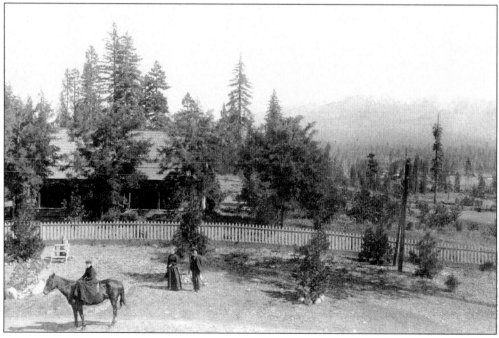

Two of the area's early pioneer families united when Mary Sullaway (right) and George McCloud (below), son of Ross and Mary McCloud, were married at Forest Home in 1886. George McCloud worked on the Central Pacific Railroad survey in the Sacramento River Canyon during its construction. He and Mary later moved to the Soda Springs Hotel, which they ran for a number of years. In 1911, he was employed by the Sisson Fish Hatchery, and the family made their home near there. (Both courtesy Siskiyou County Museum.)

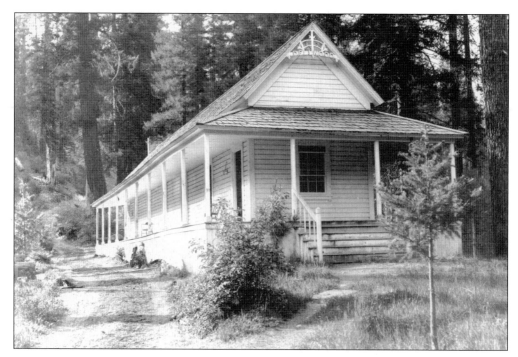

Justin Sisson built a fishing resort on the McCloud River, sometimes called "Sisson's-on-the McCloud," where he took his guests fishing and hunting during the summer. (In 1917, a caretaker for the estate that acquired the property reported that Sisson's stagecoach could still be found in a barn there.) Lodging was built on Horseshoe Bend or "The Bend" where the McCloud River made a turn. These photographs were taken in 1888 or 1889 and show the back of the lodge and other guest quarters. (Both courtesy Siskiyou County Museum.)

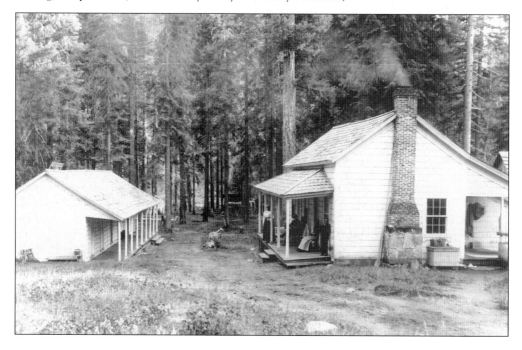

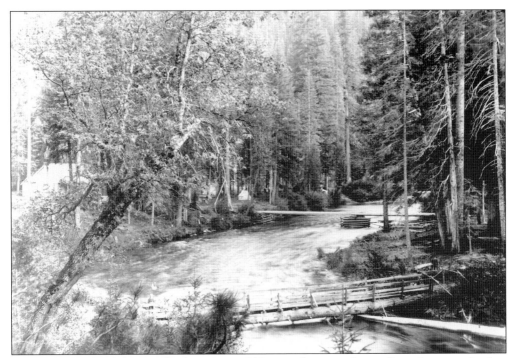

This photograph of the McCloud River in 1889 was taken near Justin Sisson's resort. Anglers were attracted to the river's pure glacial waters where a prize catch would be what was then called a "Dolly Varden" trout (in California found only in the McCloud River). George McCloud also owned a fishing resort on the McCloud River. (Courtesy Siskiyou County Museum.)

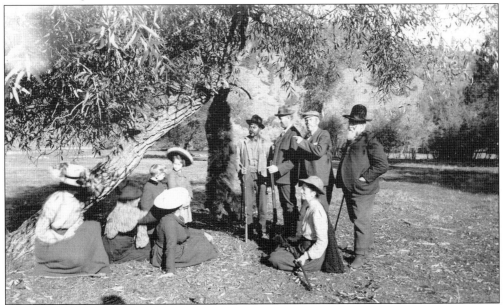

Jerome Fay (right), who had been Justin Sisson's business partner, a hotel proprietor, and a mountain guide, is pictured in the early 1900s with unidentified friends after a successful bear hunt. Mount Shasta is still a habitat for bears, although the grizzly bear is now extinct here. (Courtesy Siskiyou County Museum.)

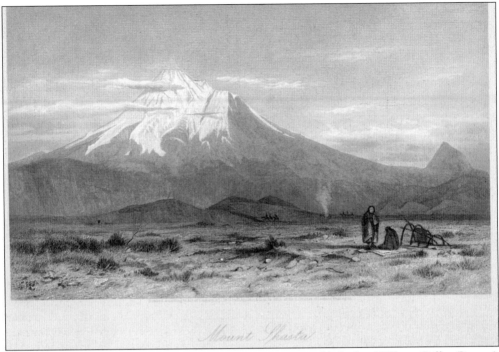

Mount Shasta

These engravings of the western side of Mount Shasta were published in William Cullen Bryant's *Picturesque America* in the 1870s. Robert S. Giford was the painter of the engraving above, published in 1873, which shows a small hut commonly used by the Native Americans of the area. The bottom engraving is by well-known landscape painter James D. Smillie. Both tepees and horses were not usually found in the Mount Shasta area, so there is speculation that the people here may have not been Native Americans but possibly an expeditionary party, which used tepees to camp. (Both courtesy College of the Siskiyous Library.)

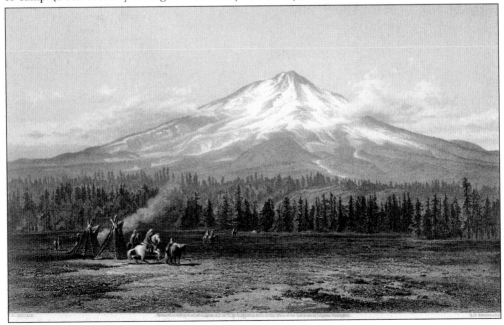

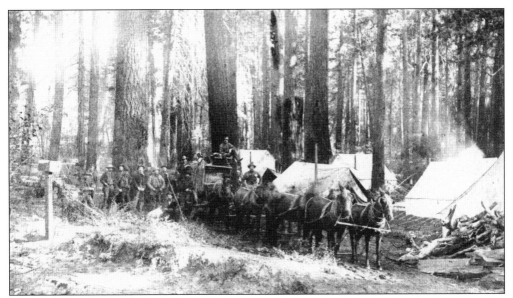

By 1870, the Central Pacific Railroad had been constructed to Redding. The railroad bought approximately 43 miles of the turnpike road in the Sacramento River Canyon where this survey camp (above) was photographed. Approximately 2,000 men, mostly Chinese, were laying the tracks north of Delta. In May 1885, Lydia Sisson wrote her sister that the railroad "is still at a stand at Delta and will probably remain there for another year at least." The photograph below of a railroad crew and their steam shovel was taken between Sisson and Mott, one of the railway camps that became a small town in the early 1900s. (Both courtesy Siskiyou County Museum.)

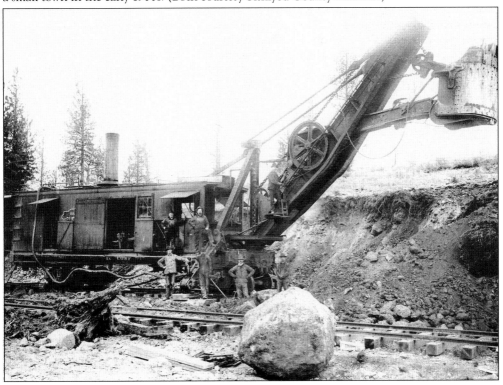

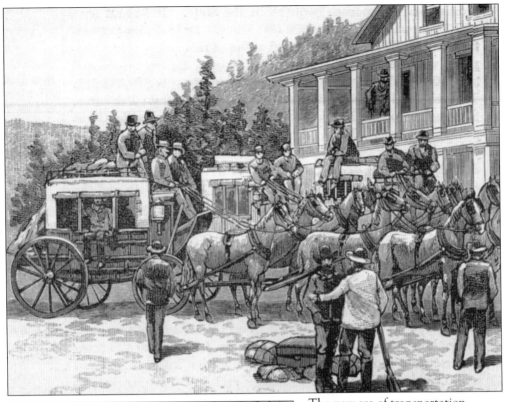

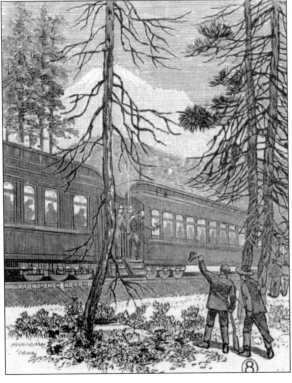

The new era of transportation, which would forever change Strawberry Valley, is illustrated in these etchings published in *Frank Leslie's Illustrated Newspaper* on December 24, 1887, entitled "Last Days Staging" (above) and "First Through Train Via Mt. Shasta from San Francisco to Portland" (left) by Howard C. Tibbits. On November 8, 1881, Justin Sisson and Jerome Fay sold the first right-of-way on land located one mile east of Berryvale to the Pacific Improvement Company, the Central Pacific Railroad's land holding company. Under the deed of August 1886, the town of Sisson was established. (Both courtesy College of the Siskiyous Library.)

Three

"AND CONQUER I WILL THIS MOUNTAIN"

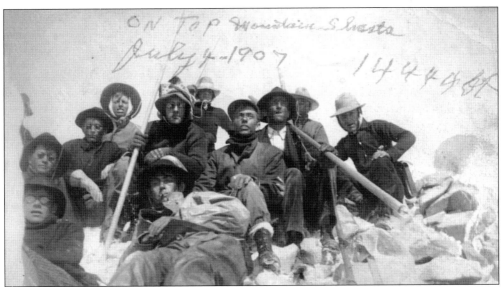

Since the first documented ascent by Capt. Elias D. Pierce and a group of men on August 14, 1854, Mount Shasta has become a popular destination for mountaineers. This group was photographed on Mount Shasta's summit on July 4, 1907. Although no one really knows for sure, Native Americans had not climbed Mount Shasta beyond the timberline prior to the white man's arrival. Joaquin Miller learned that it is because of their "profound veneration for the Great Spirit, the Great Spirit who dwells in this mountain with his people as in a tent." The first ascent by scientists was made by the California Geological Survey, led by Prof. Josiah Dwight Whitney in September 1862. In 1875, the U.S. Coast and Geodetic Survey constructed a 14-foot-high metal signal tower, capped by a nickel reflector, on the summit of Mount Shasta. The tower's purpose was to assist with topographical mapping using a method called triangulation with other fixed sites. It later became an important symbol for climbers of Mount Shasta who had reached the summit. (Courtesy College of the Siskiyous Library.)

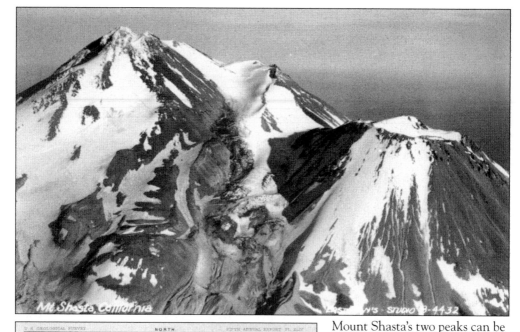

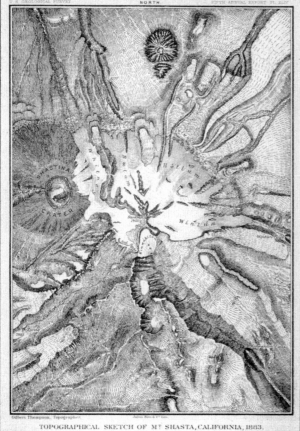

Gilbert Thompson, Topographer. Julius Bien & Co. Lith.

TOPOGRAPHICAL SKETCH OF M? SHASTA, CALIFORNIA, 1883.

Glaciers [] Scale Névé Fields []

one mile

Mount Shasta's two peaks can be seen in this breathtaking aerial shot of the mountain (above). The first glacier was officially discovered by geologist Clarence King in 1870, although Israel S. Diehl mentioned glaciers after his solo climb on October 11, 1855. The topographical sketch (left) was made by the U.S. Geological Survey in 1883 without use of an airplane, a remarkable feat. John Wesley Powell named five of the glaciers on his climb in 1880. Whitney, the longest glacier, was named after Prof. Josiah D. Whitney, while the other glaciers were given Wintu names—Bolam meaning "great"; Hotlum, the largest glacier, meaning "steep rock"; Wintun, which may actually be two glaciers, named after the Native Americans; and Konwakiton, meaning "dirty" or "muddy." (Above, photograph by J. [Jervie] H. Eastman; both courtesy College of the Siskiyous Library.)

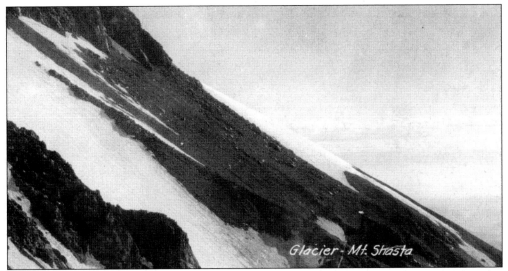

Mount Shasta has the largest number of glaciers contained on one peak in California. This close-up photograph of one of the glaciers (above) was taken in 1922 by P. (Paul) J. Standar. The topographical map (below) was published in 1908 by the U.S. Geological Survey. Recent studies have indicated there may be 7 or even 10 glaciers on Mount Shasta. The two other glaciers that were added to the 1986 U.S. Geological Survey topographic map are Mud Creek and Watkins, named after J. Harold "Harry" Watkins, who spent over 20 years trying to get this glacier officially recognized. (Both courtesy College of the Siskiyous Library.)

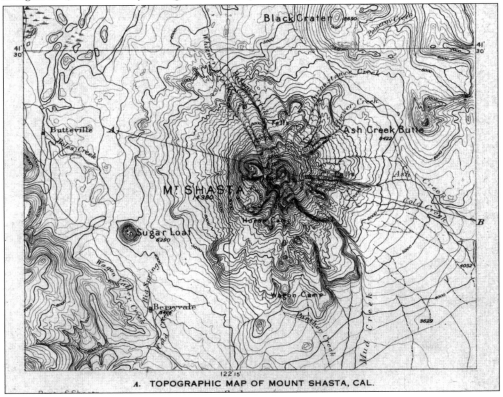

A. TOPOGRAPHIC MAP OF MOUNT SHASTA, CAL.

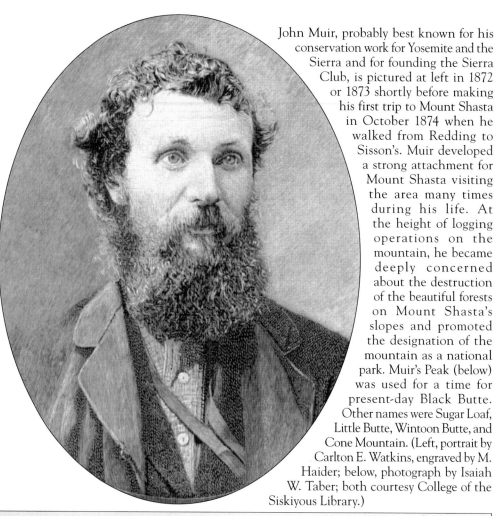

John Muir, probably best known for his conservation work for Yosemite and the Sierra and for founding the Sierra Club, is pictured at left in 1872 or 1873 shortly before making his first trip to Mount Shasta in October 1874 when he walked from Redding to Sisson's. Muir developed a strong attachment for Mount Shasta visiting the area many times during his life. At the height of logging operations on the mountain, he became deeply concerned about the destruction of the beautiful forests on Mount Shasta's slopes and promoted the designation of the mountain as a national park. Muir's Peak (below) was used for a time for present-day Black Butte. Other names were Sugar Loaf, Little Butte, Wintoon Butte, and Cone Mountain. (Left, portrait by Carlton E. Watkins, engraved by M. Haider; below, photograph by Isaiah W. Taber; both courtesy College of the Siskiyous Library.)

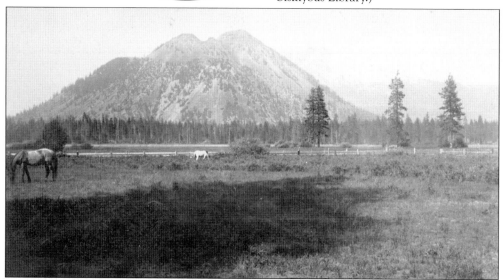

On April 29, 1875, John Muir, Capt. Augustus F. Rodgers of the U.S. Coast and Geodetic Survey, and guide Jerome Fay climbed to Mount Shasta's summit to take surveys for the placement of a geodetic signal tower to be used for future topographical mapping. This etching (right) depicts Muir and Fay's climb the next day to take barometric readings and was written about in Muir's "The Perilous Night on Mount Shasta." The two climbers became trapped on the summit during an unexpected snowstorm, kept alive by lying near the summit's hot sulfur springs. Later Justin Sisson transported the tower up the mountain using wagons, then mules, and finally by Native Americans, who carried the pieces to the summit. After its construction (below), the reflected light from the tower's cone could be seen from the valley. Muir suffered frostbite for the rest of his life and never climbed Mount Shasta again. (Both courtesy College of the Siskiyous Library.)

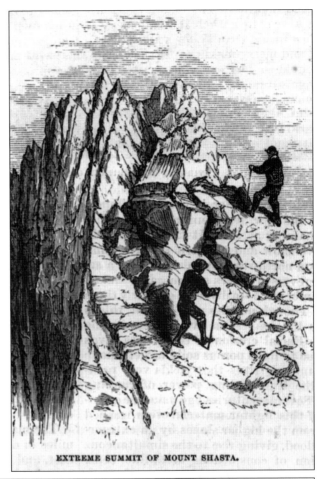

EXTREME SUMMIT OF MOUNT SHASTA.

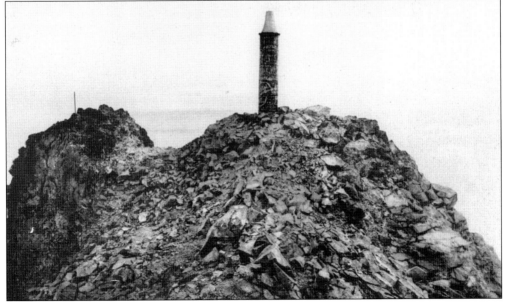

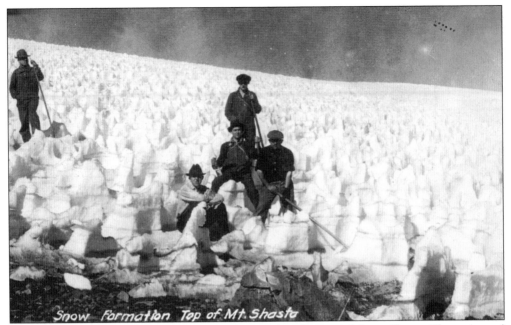

These mountaineers are posed among jagged pinnacles of snow on Mount Shasta. These unusual formations, known as Nieve Penitente, or Penance Snow, are sculpted by sun and wind. (Photograph by P. J. Standar, courtesy College of the Siskiyous Library.)

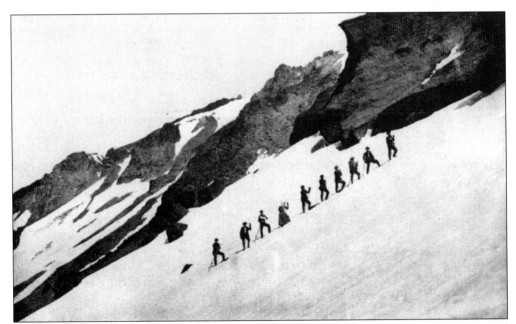

These climbers are ascending the mountain on the route up Avalanche Gulch, one of several glacier-carved valleys on the mountain. The ascent is not considered a very difficult one by mountaineering standards. However, before attempting a climb to the summit, climbers should be prepared with the appropriate equipment and consult local mountain guides. (Courtesy Siskiyou County Museum.)

One thousand feet above Konwakiton Glacier is a prominent feature on Sargent's Ridge called Thumb Rock. At an altitude of 12,923 feet, it can be seen from downtown Mount Shasta. In 1937, a 14-mile natural ski run, the longest in the world at the time, was laid out on Mount Shasta. The "Kehrlein Schuss" started at Thumb Rock and ended at the town of Mount Shasta. (Photograph by P. J. Standar, courtesy College of the Siskiyous Library.)

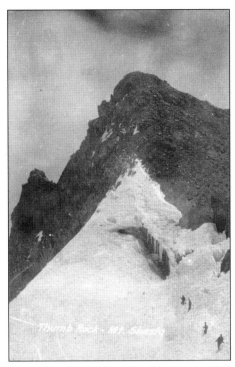

This group of mountaineers illustrates the type of dress worn by women and men in the early days of climbing. On September 9, 1856, the first women to reach the summit of Mount Shasta were Mary A. White, Harriet Catherine Eddy, Mary (Campbell) McCloud, Ann A. Lowery, and Susan (Hogeboom) Gage, accompanied by Capt. Elias D. Pierce and a group of 9 or 10 men. (Courtesy College of the Siskiyous Library.)

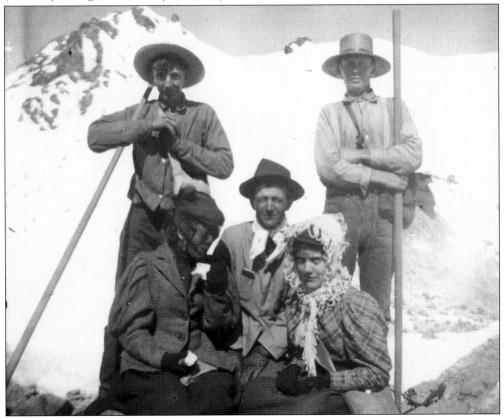

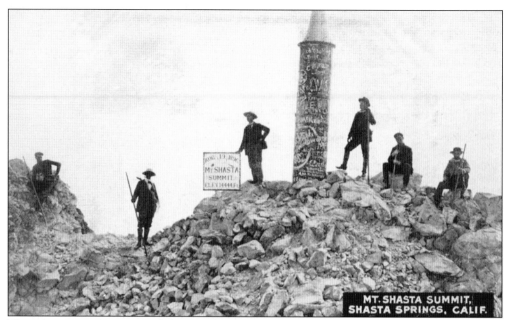

These mountaineers are posed above in this photograph taken in 1896 next to the geodetic signal tower, the symbol of a successful ascent. The names and initials written on the tower are now being studied to track the history of summit climbs. In 1862, the California Geological Survey calculated the altitude of 14,444 feet using barometric pressure, which was in use for many years and can be seen on the sign. During the survey, Prof. William H. Brewer wrote that the summit was already a "California Conglomerate, a mixture of tin cans and broken bottles, a newspaper, a Methodist hymn book, a pack of cards, an empty bottle." In 1903, the signal tower disappeared during a snowstorm but was found lying located below the summit's southwest face (below); the top cone was transported down the mountain and is now on display at Mount Shasta's Sisson Museum. (Below, photograph by P. J. Standar; both courtesy College of the Siskiyous Library.)

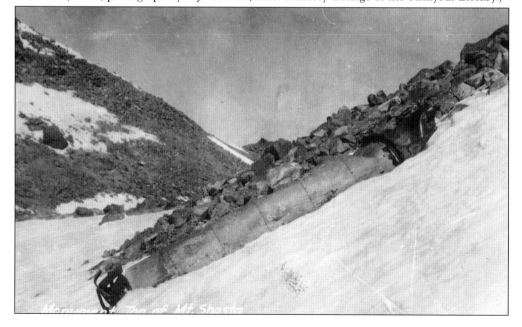

The first animals to reach the summit were two mules named Dynamite and Croppie on September 10, 1883. However, it was the first horse, Jump Up, that became famous. On September 23, 1903, Tom Watson guided Alice Cousins on Jump Up to the summit, pictured here with W. B. Beam and artist Valentine. They had actually made the climb three weeks earlier, but when their photographs came out black, they had to return to retake the photograph, later published in 1936 in *Ripley's Believe It or Not!* (Courtesy College of the Siskiyous Library.)

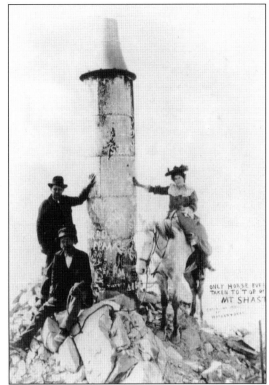

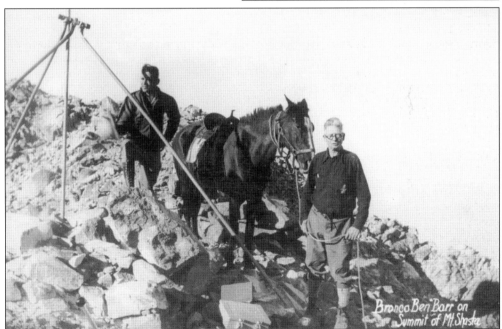

In September 1936, John M. Schuler (right), his son John W. Schuler (left), and Henry Rische re-created Tom Watson's climb with their horse Bronco Ben Barr. Since the authenticity of the previous climb had been doubted by locals, Schuler wanted to prove it could be done and had hopes of building a horse trail up to the summit. (Courtesy College of the Siskiyous Library.)

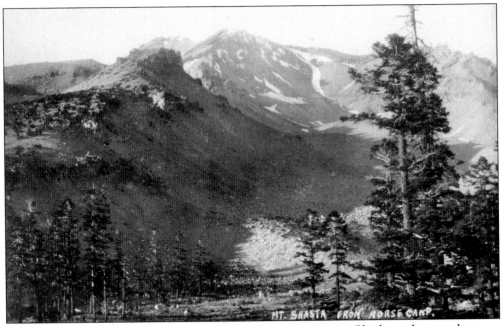

MT. SHASTA FROM HORSE CAMP.

Climbers who stayed at Sisson's traveled the 8-mile Sisson-Shasta Trail up the mountain to Horse Camp (above), located at an elevation of 7,880 feet at timberline, where they camped before attempting the ascent. Matthew Hall McAllister, pictured at left in 1921, was a San Francisco businessman and dedicated patron of the Sierra Club, who organized and financed the construction of a lodge at Horse Camp. The architectural firm C. T. Gutleben and Brothers, designers and engineers for the Golden Gate Bridge, Bay Bridge, and Yosemite's Glacier Point Hotel, were hired to design the Shasta Alpine Lodge. The original plan was modeled after Tuolumne Meadows' Parson's Lodge using granite blocks and a white tile roof. (Both courtesy College of the Siskiyous Library.)

The plan for the Shasta Alpine Lodge was later modified to a metal roof and local lava rock. Construction began in July 1922 and the lodge was completed and dedicated in July 1923. Chief Yola Wintu wrote this ode for the dedication held on July 4: "Land of the turquoise sky / Eight thousand feet above worry level. Where the planets shine brightest / On the fringe of the covering snow. Where the pine grouse sounds his drum / And the Clark's crow feeds its young. Where the soaring eagle scanning wide / And the frisky chipmunk seeks to hide. The hunted stag finds his well earned rest / And the eager mountaineer seeks his quest. There is where I wish to go / To the land of the lasting ice and snow." (Both courtesy College of the Siskiyous Library.)

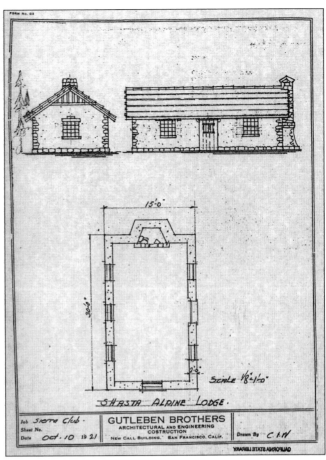

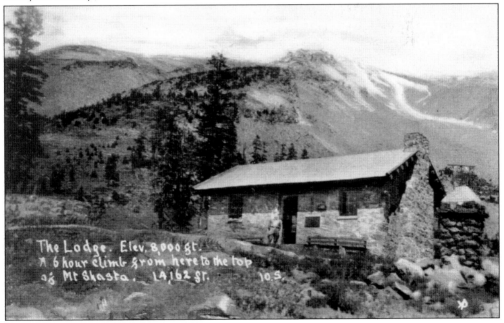

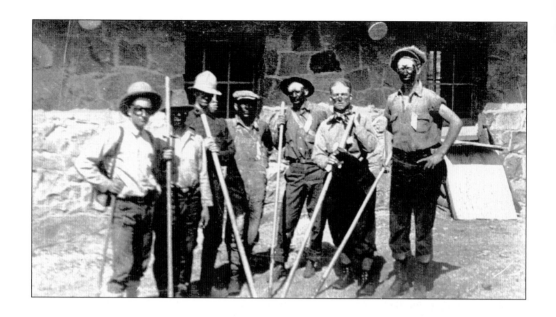

On July 5, 1925, a race to the summit of Mount Shasta from Horse Camp was held as part of the annual Fourth of July festivities. These seven contestants are posed above in front of the Shasta Alpine Lodge prior to starting the race, their faces blackened to protect them from snow burn. The photograph below shows the racers leaving the lodge as they attempt the 6,000-foot ascent—a total of 3 miles. Harry Babcock had held the record since August 12, 1883, when he climbed Mount Shasta in 3 hours and 40 minutes. (Both courtesy Siskiyou County Museum.)

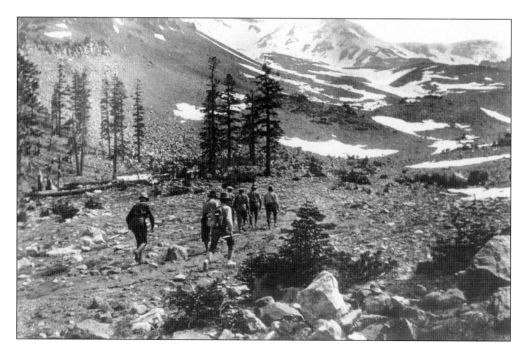

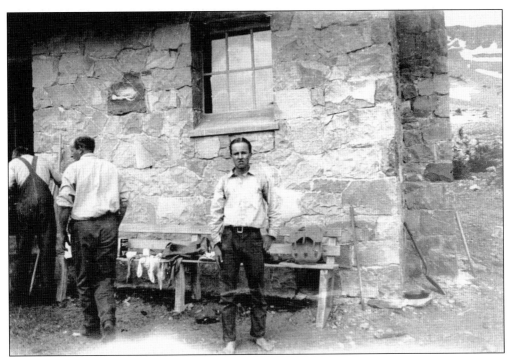

Eighteen-year-old David Lawyer of Pasadena (above) won the race in a record 2 hours and 24 minutes. Record holder Harry Babcock donated the J. H. Sisson Memorial Cup to the winner. On July 5, 1985, the 60th anniversary of the Mount Shasta Marathon, the record was broken by Robert Webb, former lodge custodian, who made the climb in 1 hour and 45 minutes. (Courtesy Siskiyou County Museum.)

"Old Mac" Olberman was the first caretaker for the Shasta Alpine Lodge at age 60; he is pictured at right in 1932 at the head of Olberman Causeway, a half-mile rock path he built to help climbers. Serving as caretaker for 12 years, he was self-educated in astronomy, mathematics, German, and Norwegian, and he translated and published a work by Ibsen. (Photograph by Edward Stuhl, courtesy California State University, Chico, Meriam Library, Special Collections.)

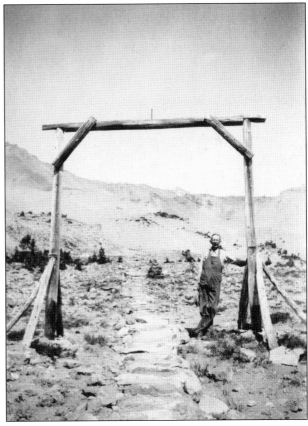

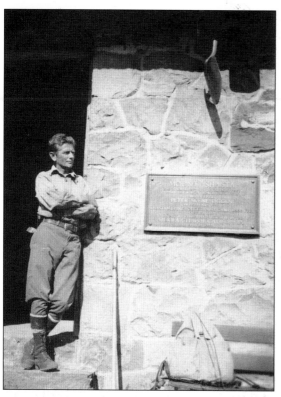

Standing in front of the Shasta Alpine Lodge in August 1932 is Edward Stuhl (left), a talented mountaineer, naturalist, writer, and artist. Upon his first sight of Mount Shasta in 1917, Stuhl stated "and conquer I will this mountain," and he would, climbing the mountain 22 times, documenting his ascents with photographs and notes and painting most of its wildflowers. Stuhl served as lodge custodian for 10 years and became passionate about preserving Mount Shasta. On his third ascent of Mount Shasta in September 1925, he stopped to heat water from melted snow and condensed milk over boiling springs (below). "It was cold enough that I had to wear heavy gloves during the process." Stuhl took readings of the summit hot springs seven summers in a row, the temperature varying between 162 and 184 degrees. (Below, photograph by Herbert Clark; both courtesy California State University, Chico, Meriam Library, Special Collections.)

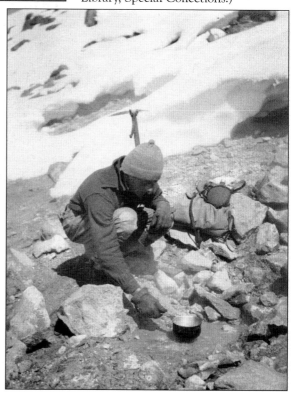

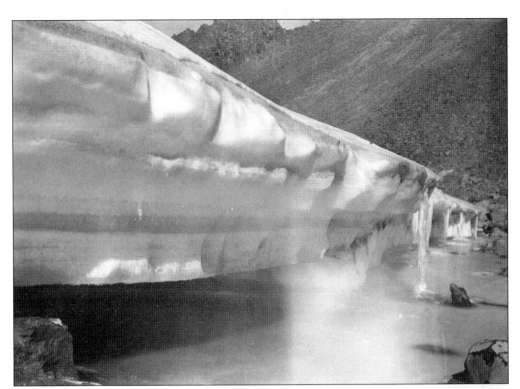

Edward Stuhl served as custodian for Charles S. Wheeler's estate on the McCloud River (formerly Sisson's fishing resort) from 1924 to 1927. In August 1924, Wheeler's daughter-in-law Helen Wheeler accompanied Stuhl on his second ascent of Mount Shasta, where Stuhl noticed "a small pool of water filling past of the hallow at the 11,000 foot terrace in the vicinity of Battlement Rock. When we reached the pool we estimated it to be six to eight feet deep and there still was a layer of ice on its bottom and a mass of white snow-ice overhung it cavern-like on the south side. Helen wanted to know whether that pool had a name; it had none and solemnly I baptized it 'Lake Helen'." In September 1932, Helen was photographed standing above Squaw Creek Meadows (right). (Both photographs by Edward Stuhl, courtesy California State University, Chico, Meriam Library, Special Collections.)

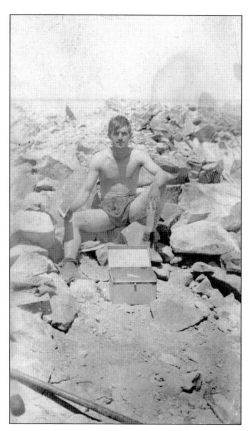

This young man (left) sits atop the summit with the summit register box in about 1915, one of 10 men (below) who had climbed Mount Shasta with the original intent of holding a boxing match on the summit. When they finally reached the summit, they were too tired! In 1868, the first summit register had been placed on Mount Shasta by Justin Sisson. In 1900, Sisson's relatives removed it and donated it the University of California, Berkeley, and a new one was put in its place. (Both courtesy College of the Siskiyous Library.)

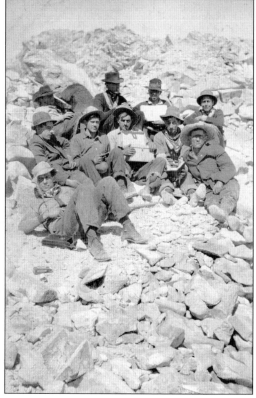

Edward Stuhl is carrying the record book and aluminum box of the Mazama Mountaineering Club of Portland, Oregon, as he crosses the ice field approaching the summit. This is Stuhl's 11th ascent of Mount Shasta on September 13, 1931. (Photograph by Charles Stewart, courtesy California State University, Chico, Meriam Library, Special Collections.)

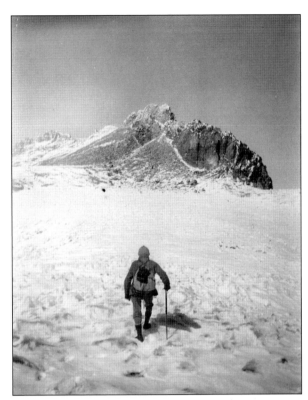

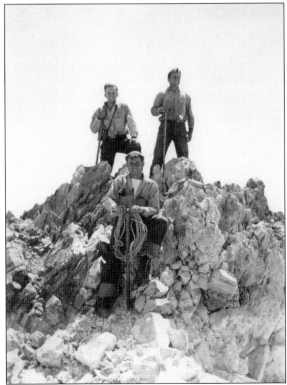

Accompanying Edward Stuhl on his 13th ascent in August 1933 are Marvin Pomeroy (left), Francis Steckmest (center), and Charles S. Wheeler III, who made the climb in 5 hours and 25 minutes. Stuhl stated that Steckmest was enthusiastic about the climb and would make the best mountain climber. (Photograph by Edward Stuhl, courtesy California State University, Chico, Meriam Library, Special Collections.)

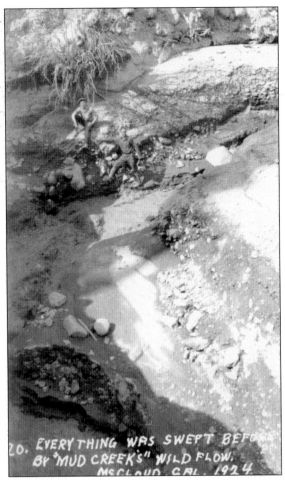

20. EVERYTHING WAS SWEPT BEFORE BY "MUD CREEK'S" WILD FLOW. McCLOUD CAL. 1924

In August 1924, melting snow and ice from the Konwakiton Glacier sent glacial water, mud, and rocks of all sizes surging down Mud Creek Canyon, east of McCloud. This mudflow or *jokulhlaup*, an Icelandic term meaning "glacial outburst flood," sent 10 feet of mud over an area 5 miles long and 1 mile wide, devastating the McCloud area. These U.S. Forest Service employees in the top photograph are inspecting the mud flow. The bottom photograph shows a bed of boulders 15 feet deep below a telephone wire that had originally been 18 feet off the ground. (Both courtesy College of the Siskiyous Library.)

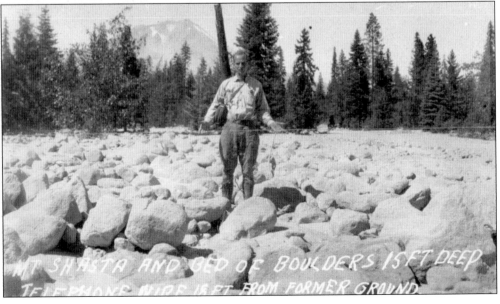

MT SHASTA AND BED OF BOULDERS 15 FT DEEP
TELEPHONE WIRE 18 FT FROM FORMER GROUND

Four

GREETINGS FROM SISSON

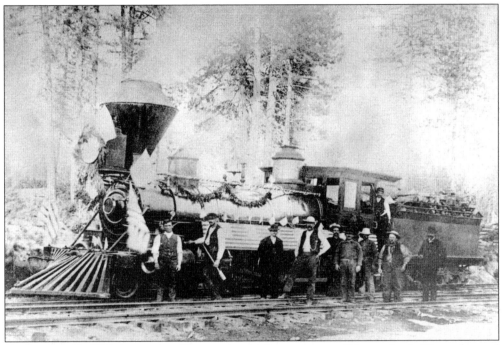

On October 29, 1886, lots were sold at auction in the new town of Sisson. Justin Sisson donated land for the town's new school and a number of streets were named after his family: Jessie and Ivy Streets for his daughters; Field Street, his wife's maiden name; and Alma Street for his sister-in-law. In November 1886, the railroad was completed, and in December, the first train arrived in Sisson. The train pictured here is decorated in flags and bunting, a special way to celebrate Sisson's first Fourth of July in 1887. In its early years, there was a "boomtown" mentality surrounding the new town. New businesses, particularly hotels and saloons, were quickly built to serve the growing population who arrived to work for the railroad and lumber industries. While structures made of wood could be quickly built, they were also good fuel when mixed with oil lanterns and a "whiskey row." Sisson's downtown district was destroyed by several fires throughout its early history. The few stone structures that were built survived. (Courtesy Siskiyou County Museum.)

This scene of downtown Sisson (above) after a snowstorm is one of the earliest known photographs of the town, taken in 1886 or 1887. A. E. Doney General Merchandise on the left was owned by Albert Doney, a telegraph operator and one of Sisson's first Wells Fargo agents. He later worked for the McCloud Lumber Company supervising Chinese laborers who cut and stacked firewood along the railroad tracks. Across the street was the Sisson Depot Hotel, c. 1888 (below), a large two-story structure featuring a waiting room with a fireplace and a 250-seat dining room that served passengers when the trains made their regular stops there for meals. As part of the agreement with the railroad, Justin Sisson operated the restaurant/hotel. On October 10, 1887, the first passenger train on the San Francisco to Portland route stopped in Sisson. (Both courtesy Siskiyou County Museum.)

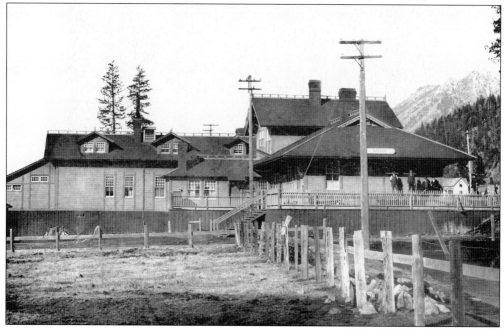

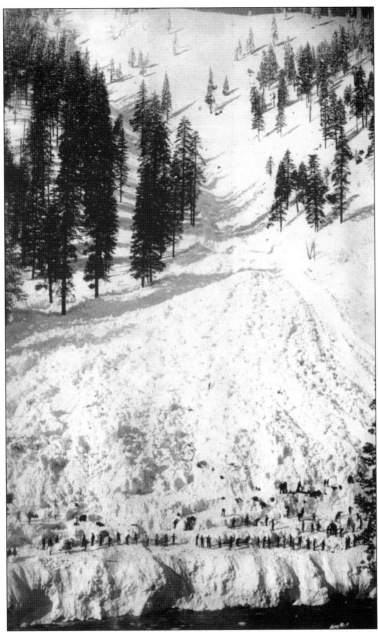

In the winter of 1889–1890, the Mount Shasta area was hit by a severe system of storms. The bad weather began in late October 1889 with heavy rains, and snow began falling in early December. May Southern, a Southern Pacific telegrapher at Sim's Station, wrote in January 1890 that they were the "fiercest storms that ever roared down the Sacramento Canyon." At one point, temperatures dropped to 30 degrees below zero. Stranded and buried in the snow was Train No. 15, its passengers running low on food, water, and fuel. The avalanche shown hit the tracks at Upper Soda Springs, completely burying the snowplow and engine and damming the Sacramento River for a time (the small dark spots are men digging them out). In Sisson, buildings were buried to the second story or collapsed, and provisions became low. Cattle, horses, and deer died by the thousands. (Courtesy College of the Siskiyous Library.)

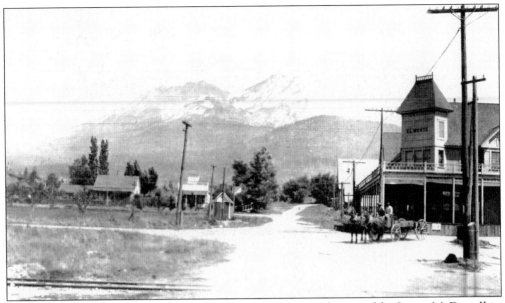

One of the leading hotels in Sisson was the El Monte Hotel, opened by James McDowell in 1887 on the corner of Walnut and Alma Streets. It contained a large saloon, a gambling area, and a pet bear named Sallie who was chained on the porch. The hotel was later remodeled to include dormers, a second-story porch, and a barbershop where patrons could take baths. Under the ownership of James "Red" McCoy, it burned in the April 1896 Whiskey Row fire. Rebuilt, it changed ownership numerous times until it burned again in the downtown fire of 1917. (Above, courtesy Siskiyou County Museum; below, courtesy College of the Siskiyous Library.)

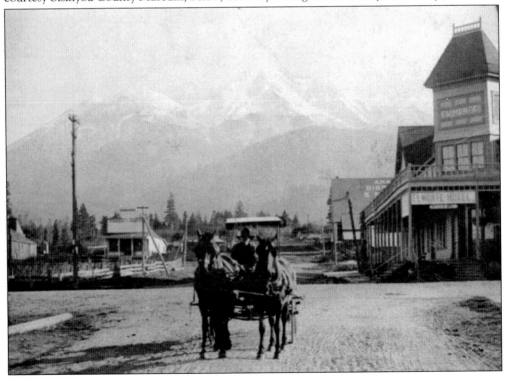

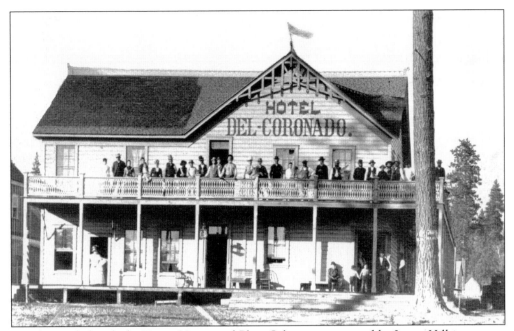

Another early hotel, the Forest House and Plaza Saloon, was opened by James Hill in an area known as "Nob Hill" (Walnut and Jessie Streets). Under Peter and Sarah McBride's ownership, the name was changed to the Del Coronado Hotel, pictured here in 1894. Two elegant hotels with similar names were being constructed in California during this time: the Del Coronado of San Diego and the Del Monte of Monterey. (Courtesy Siskiyou County Museum.)

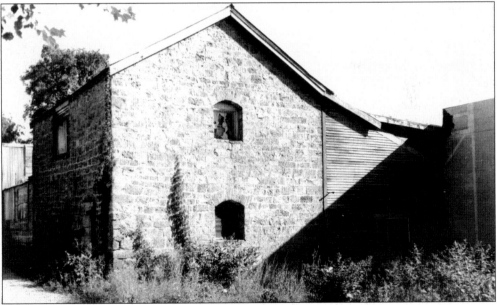

In 1888, Peter Mugler opened a saloon in downtown Sisson. In about 1890, he started a brewery on the corner of Chestnut and Lake Streets, pictured here. Sisson's first stone building, it was constructed of local lava rock 2 feet thick, which kept the interior cool. Ice cut from a pond on Lake Street was slid down a chute to the basement, where a small spring ran year-round. (Courtesy Siskiyou County Museum.)

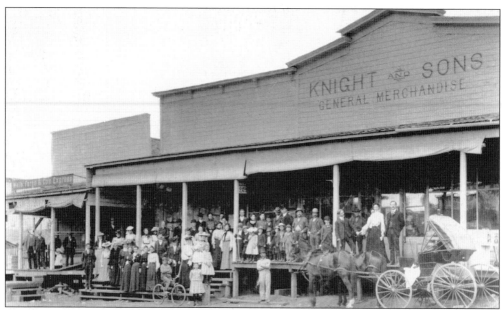

This large crowd (above) is posed in front of Knight and Sons General Merchandise in the late 1890s with James Knight, far right, and Elma Montgomery (Kuck), second from right, (the rest are unidentified). A small dry goods store and the Wells Fargo office, far left, were owned by John M. Schuler, who served as the Wells Fargo agent from 1894 to 1910. Schuler and Merton J. Knox would later purchase Knight and Sons to form the Schuler-Knox Company. These buildings, located between Lake Street and McCloud Avenue, would later be destroyed in one of the downtown fires. On the corner of Chestnut and Castle Streets, the Carlton Blacksmith Shop, pictured (below) in 1894, was the first wagon and blacksmith shop in Sisson. Its owner, James Carlton, also served as the town's undertaker. (Both courtesy Siskiyou County Museum.)

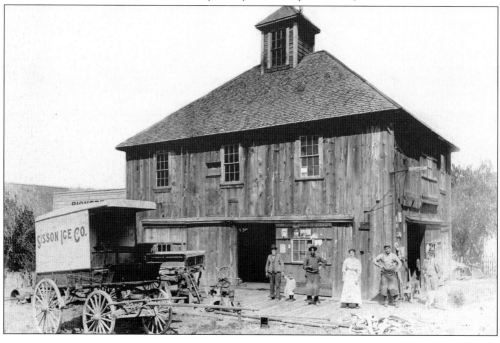

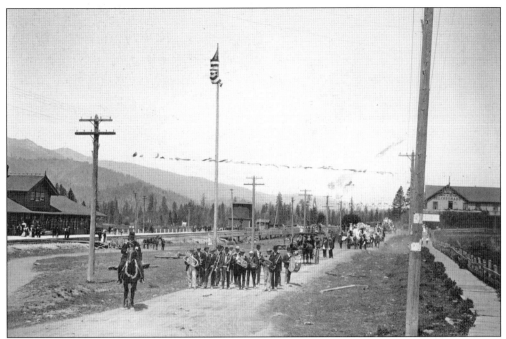

This photograph by C. R. Miller was taken during the annual Fourth of July Parade looking north on Walnut Street. The Del Coronado Hotel is on the right and the railroad depot is on the left. A typical Sisson Fourth of July celebration as it appeared in a 1904 newspaper included a parade; horse, bicycle, and foot races; a grand ball; and a baseball game. Many of these traditions continue to this day. (Courtesy Sisson Museum.)

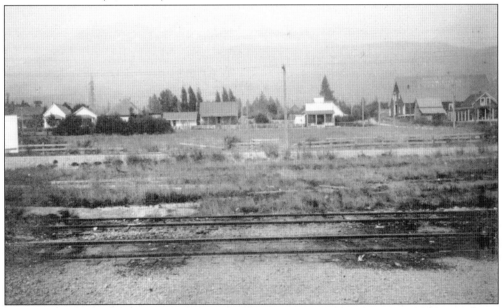

To the right of the Del Coronado Hotel was a large field called Crocker Plaza on the northeast corner of Alma and Walnut Streets (North Mount Shasta Boulevard). This photograph was taken from the railroad depot, which was located directly across from the plaza. A bandstand and fountain would be built there later. (Courtesy Perry Sims.)

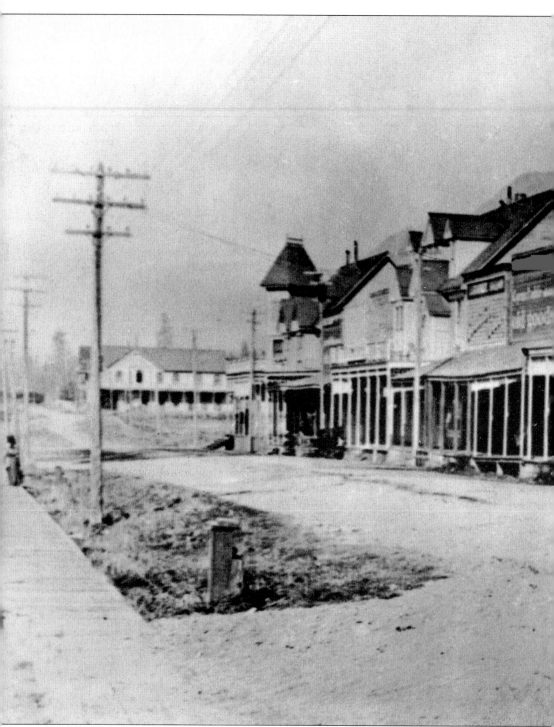

The term "Whiskey Row," pictured in 1900, was coined for Block 26 of downtown Sisson and for good reason. With the advent of the railroad and the development of logging and lumber mills nearby, Sisson was the place where men assembled to imbibe at the dozens of saloons lined up along Walnut Street (now Mount Shasta Boulevard). China Town and the Red Light District

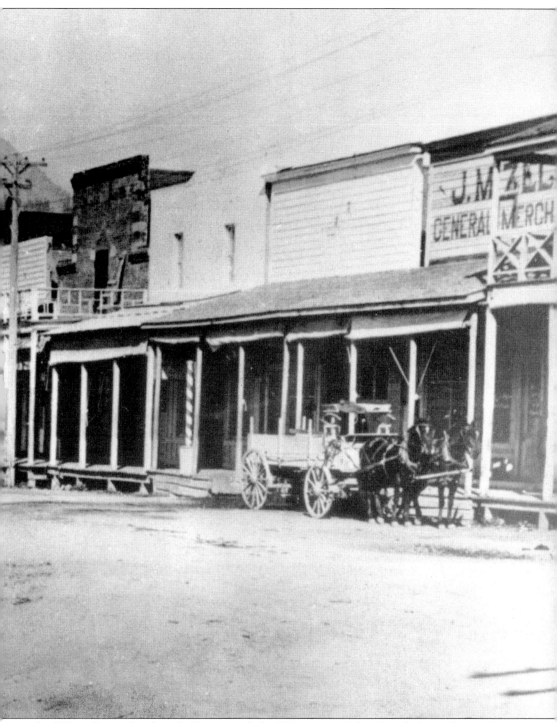

south of Water Street also provided "watering holes." Bars opened, closed, and changed ownership frequently. Local historian Perry Sims has documented at least 72 saloons that operated from the inception of Sisson to the early 20th century. Two fires burned "the row" during its heyday: the first in April 1896 and the second in 1917. (Courtesy Siskiyou County Museum.)

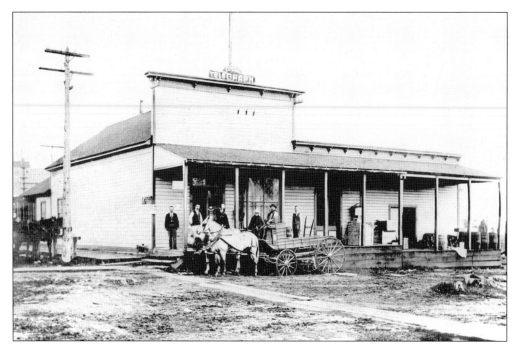

On the southwest corner of Walnut and Castle Streets in Sisson, one of the first companies to open was the Sisson-Crocker Company, shown above. It initially provided supplies for wood choppers and railroad tie makers. The manager, William Van Arsdale, was an 1874 University of California graduate in mining engineering. In 1890, Van Arsdale and his partner, George W. Scott, bought the Wright brothers' mill on Wright's Spur, two miles north of Sisson, and opened a box factory. In 1894, the name was changed to Upton, pictured below in 1898. By the early 1900s, Upton was known as a company town, with three streets, a store, post office, school, depot, boardinghouse, and restaurant. (Both courtesy Siskiyou County Museum.)

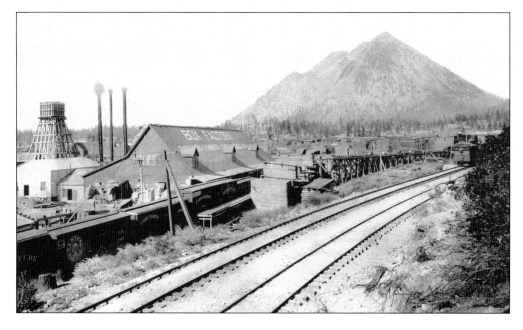

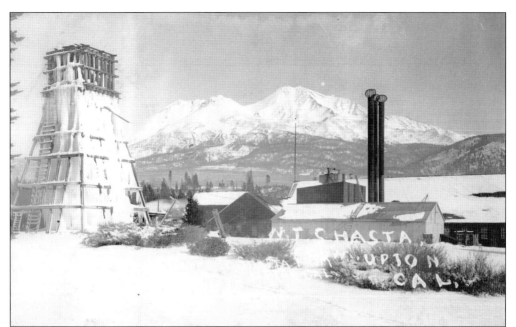

In April 1896, the McCloud Valley Railroad Company was created, forerunner of the McCloud Lumber Company. A railway was built east into the forest; logs were cut and sent back to Upton (above) by train to be processed. By the early 1900s, the company owned 10 engines and 300 cars and had built 70 miles of railroad. George Scott and William Van Arsdale bought up many of the small sawmills in the McCloud River area, where they built a town named VanDale (later renamed McCloud, pictured at right at the millponds). In 1906, they convinced Sisson's citizens to donate land for a box factory. Lumber was transported from McCloud to Sisson, instead of Upton, signaling the town's demise. By 1917, the last building was torn down. (Right, photograph by C. R. Miller; both courtesy College of the Siskiyous Library.)

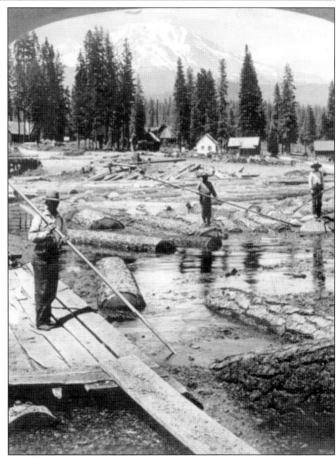

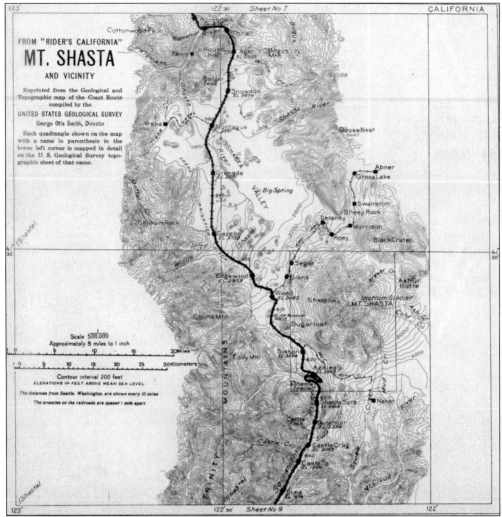

The 1925 Rider's California map of "Mt. Shasta and Vicinity" is a reprint from an earlier map, the geological and topographic map of the Coast Route compiled by the U.S. Geological Survey. On November 13, 1886, railroad construction had stopped at a temporary terminus at the south end of Strawberry Valley. This siding was named McCloud (Azalea on this map) and was built to serve the stages and freight wagons that came from Squaw Valley and the McCloud River areas. In 1898, the name was changed to Azalea, named for the wild azaleas that grew in the area. This left the name McCloud available for use, and the company town of VanDale then changed its name to McCloud, its first post office opening that same year. This "new" McCloud is not shown on the map. (Courtesy College of the Siskiyous Library.)

A flat car train is loaded with sugar pine logs near McCloud on its way to the mill in 1902. According to McCloud historian Gerald Wetzel, "The finest stand of Sugar and Ponderosa Pine in California was at one time cut flat between Dunsmuir and Mount Shasta, extending to the top of the ridge at Pierce and on down toward McCloud." (Photograph by C. R. Miller, courtesy College of the Siskiyous Library.)

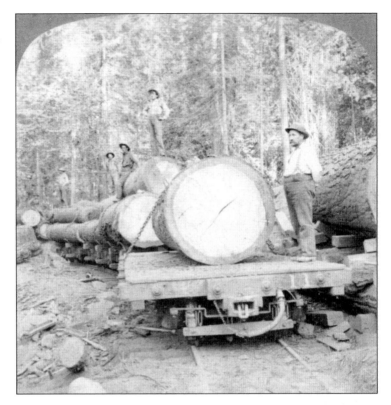

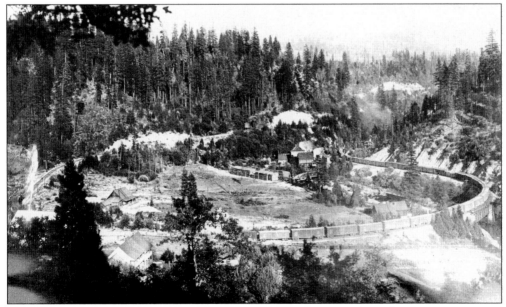

Located south of Sisson, the railroad makes a 14-degree loop just above the Cantara station at the 18th crossing of the Sacramento River. Trains heading south from Mott traveled only two to three miles per hour because of the steep grade. Many passengers left the train at the trestle and walked down a trail beside the tracks and re-boarded at a grade above Cantara. In 1890, the Cantara Lumber Company constructed a mill there. (Courtesy Siskiyou County Museum.)

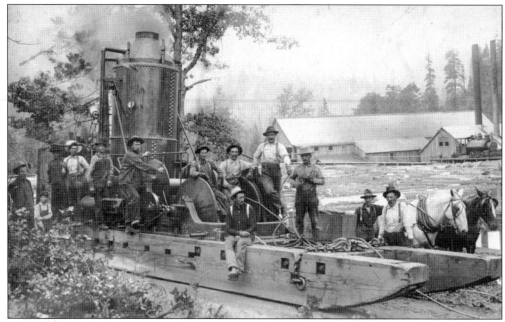

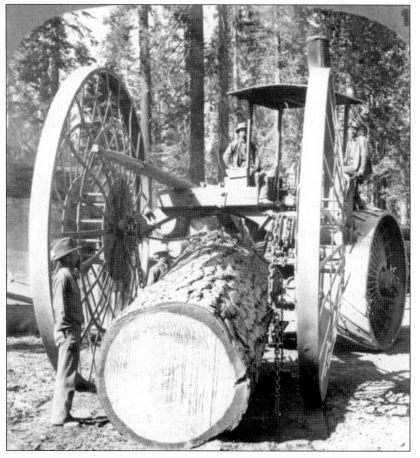

A log skidder (above) and steam traction dray (left) were used by lumbermen for felling and moving timber, as pictured in these photographs in the early 1900s. At one time, there were 52 sawmills operating between Shasta Springs and Weed. (Both courtesy College of the Siskiyous Library.)

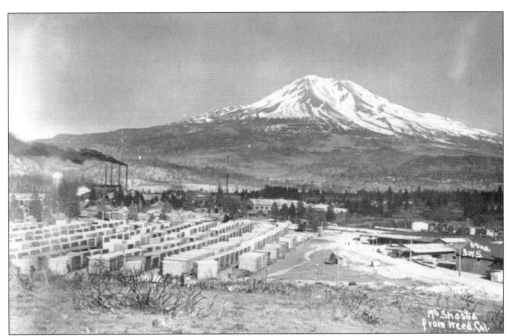

In about 1889, Abner Weed and his family moved to Sisson from Truckee, California. He first owned a mill west of Sisson, on the east slope of Mount Eddy. In 1896, Weed built a lovely home on Cedar Street in Sisson for his daughter Abigail and her husband, Alexander Albee. In 1897, he purchased 280 acres (formerly the Williams ranch), above, and a mill north of Black Butte (the old Maxwell Mill). Weed constructed a new mill on the land (right) where he also established the town of Weed. (Above, photograph by Frank Patterson; both courtesy College of the Siskiyous Library.)

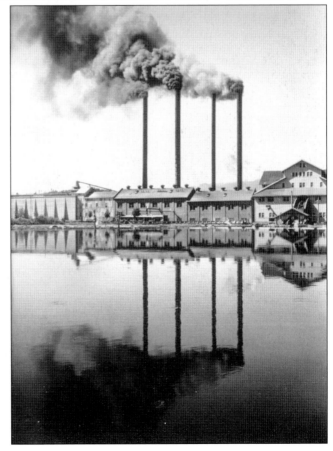

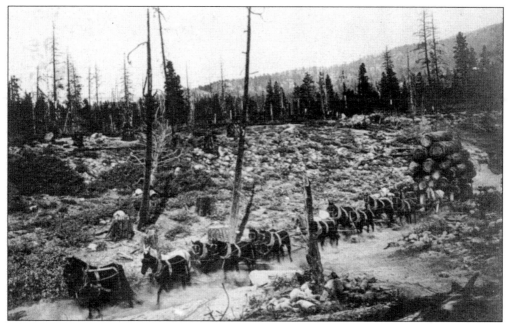

This photograph of horses and mules hauling logs down the slopes of Mount Shasta was taken south of Weed in 1906. Teams of horses and mules were used up to the mid-1920s. A steam tractor located on the right was part of the original photograph but had been cropped out. (Photograph by C. R. Miller, courtesy College of the Siskiyous Library.)

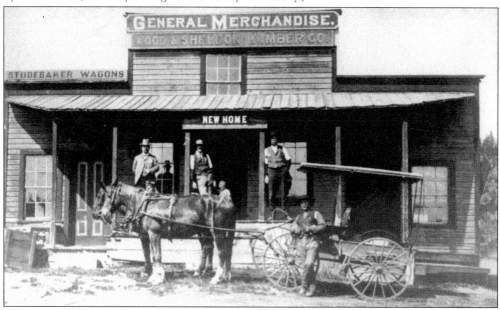

This general merchandise store at Mill Camp near Sisson was in operation since 1888. During the 1900s, the Wood and Sheldon Lumber Company, pictured here, owned and operated a sawmill, shingle mill, and logging camps at Rainbow near the Sacramento River. From left to right are H. P. Martin, John Purdy, and Darwin Alonzo "Lon" Sheldon. Edward Sheldon is next to the wagon. In 1915, the Weed Lumber Company purchased the business and the merchandise was taken by train to Weed. (Courtesy Siskiyou County Museum.)

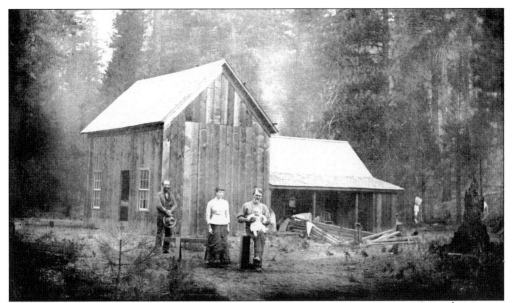

Thomas Sullivan (right), holding Lawrence, and his wife, Georgeanna Sullaway Sullivan, settled the Rainbow Ranch near Sisson. (The other man is unidentified.) Thomas worked at the Sisson fish hatchery and as a guide for fishing trips to the McCloud River. In 1898, the Sullivans sold Rainbow Ranch and moved to Shastina (now part of Weed). In 1969, a dam was built at Box Canyon on the Sacramento River, flooding Rainbow to create the Lake Siskiyou reservoir, now a popular lake for swimming, fishing, and boating. (Courtesy Siskiyou County Museum.)

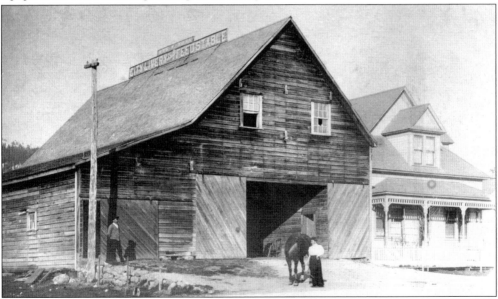

Katherine Kohn, center, operated the feed and livery stable on Chestnut Street with help from her brother-in-law, John Kohn, left, in the early 1900s. Katherine and her husband, Nicholas, had first lived in Sisson in 1888 before moving to the Sisson–Fall River Mills road in 1900, where they ran the Mountain House stage stop. After Nicholas was killed in an accident, Katherine and her five children returned to Sisson, where she started the business, and built a home in 1903. Her descendants still reside in the community. (Courtesy Siskiyou County Museum.)

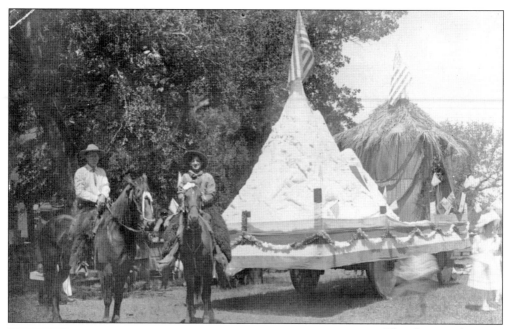

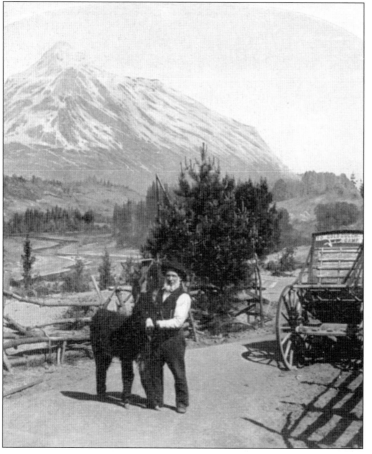

The photograph above is a replica of the town's popular icon, Mount Shasta, created as a float for one of its early parades. Replicating the mountain occurred in other locations as well. While this gold miner and donkey (left) appear to be posed in front of Mount Shasta; in fact, the whole scene was created in San Francisco at the 1894 Midwinter Exposition. As part of the fair, a 49er mining camp was built with cabins and dugouts along a gulch where people could "pan for gold." The backdrop of this scene was a painted canvas of Mount Shasta. (Left, photograph by James M. Davis; both courtesy College of the Siskiyous Library.)

Five

SHASTA'S ROAD OF A THOUSAND WONDERS

This advertisement appeared in the April 1907 issue of *Country Life in America* to promote the Southern Pacific's Road of a Thousand Wonders, showing Mount Shasta as one of its popular destinations. Upon completion of the railroad and the ease of travel it offered, the number of visitors increased, as did resorts that were built near the Sacramento River along the rail line. In addition to the early resorts of Sisson's and Soda Springs, Shasta Retreat, Shasta Springs, and Ney Springs attracted many tourists to "take the waters." Located near Mount Shasta's natural springs and waterfalls, the resorts became popular destinations for visitors who wanted an extended stay during the summer for relaxation and recreation in an idyllic setting. (Courtesy College of the Siskiyous Library.)

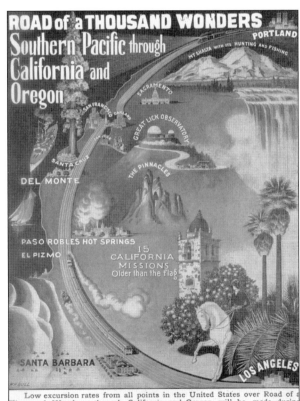

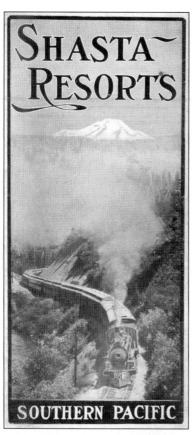

This Southern Pacific Railroad advertisement (left) promoted the Mount Shasta area and its Shasta Resorts line. Of these resorts, the Soda Springs Resort was one of the oldest still in operation (below). After Ross McCloud's death in 1868, Mary McCloud married Isaac Fry, and in 1874, they built a larger hotel, the Upper Soda Springs Hotel. Sadly both Isaac and Mary died the following winter. The hotel was then managed by George Campbell (Mary's brother) and Dick Mannon and later by Ross and Mary McCloud's children. The hotel was open in both winter and summer, serving the elite of San Francisco society, and was visited often by railroad developer Charles F. Crocker. During the railroad's construction, railroad executives made it their winter quarters. (Both courtesy College of the Siskiyous Library.)

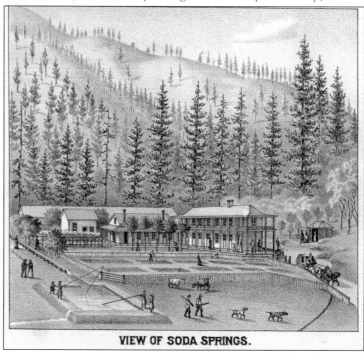

VIEW OF SODA SPRINGS.

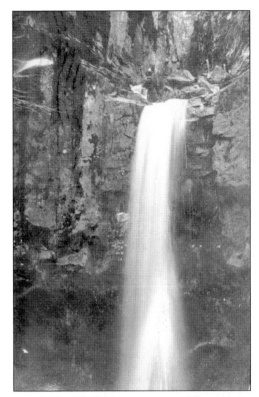

Two waterfalls are located north of Upper Soda Springs near the Sacramento River and were popular with tourists. Fed from the snowfields on Mount Shasta, these falls emerge thousands of feet below from subterranean streams. Hedge Creek Falls (right), which flows out of a seam of bedrock, may have been the hideout of Black Bart (Charles E. Boles) during his flight from authorities in the 1880s after robbing stages between Yreka and Sacramento. In 1890, trains on the Shasta Route began making regularly scheduled five-minute stops, one in each direction, for passengers to view spring-like Mossbrae Falls (below). (Below, photograph by Prentiss E. Hart; both courtesy College of the Siskiyous Library.)

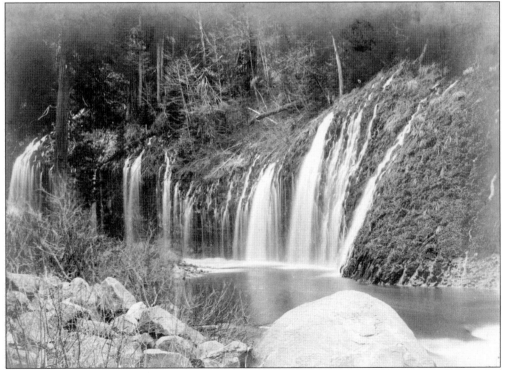

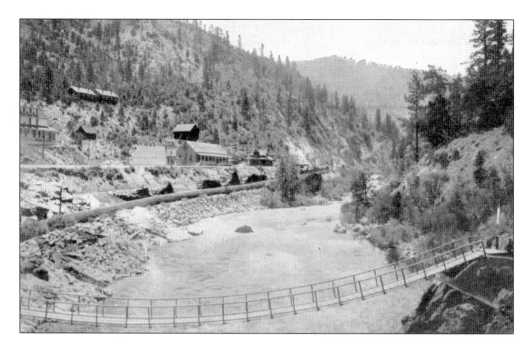

Perched above the Sacramento River, Shasta Retreat (above) was developed on 40 acres between Upper Soda Springs and Hedge Creek Cave. It was first started by the Sisters of Charity as a Catholic summer school and for use by Catholic families as a summer resort. It was later operated by the Shasta Vicino Camp Association under the auspices of the Methodist Church. In the center of the property was a spring, and five other soda springs were located within walking distance. In 1896, the railroad established a station at the retreat. (Both courtesy College of the Siskiyous Library.)

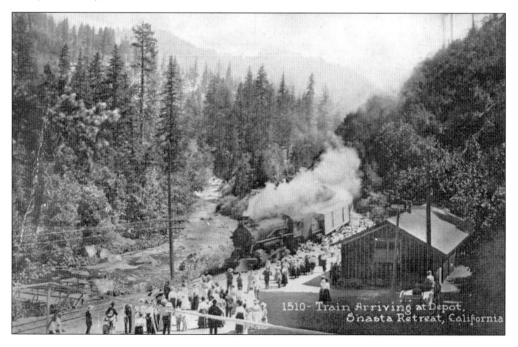

1510- Train Arriving at Depot,
Shasta Retreat, California

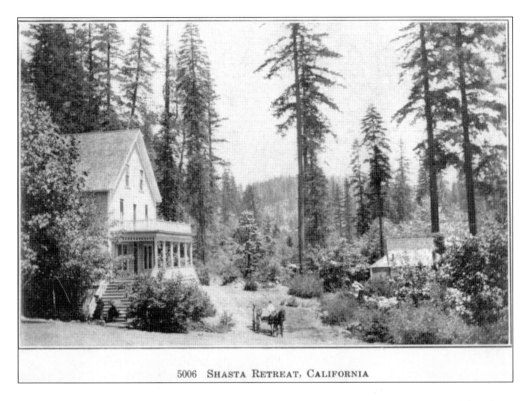

5006 SHASTA RETREAT, CALIFORNIA

Vacationers at the Shasta Retreat had the choice of staying in cottages, at the tavern (above), or in tents. Recreation included bathing in a 160-by-50-foot swimming pool (below). Chatauquas, lectures in arts, sciences, and literature, and concerts were also offered. (Both courtesy College of the Siskiyous Library.).

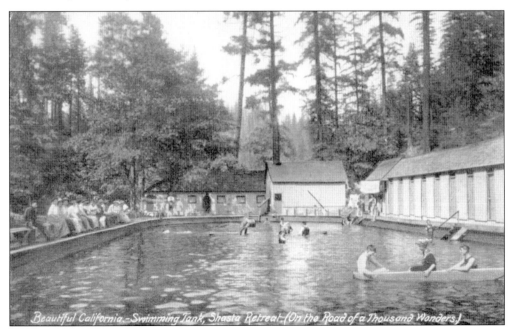

Beautiful California.–Swimming Tank, Shasta Retreat. (On the Road of a Thousand Wonders.)

Sacramento River
Shasta Springs.

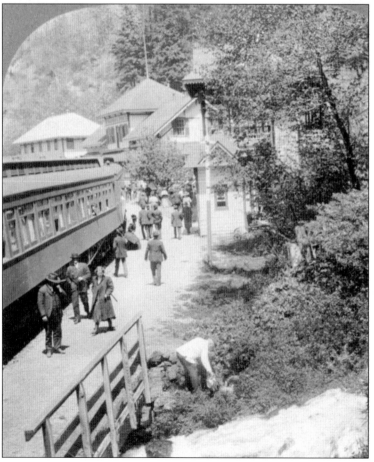

In 1886, J. J. Scott discovered mineral springs on property he had purchased between Dunsmuir and Mount Shasta on the Sacramento River, pictured above. These springs became the site of the popular Shasta Springs Resort. In 1892, the Shasta Springs station was established, left. In 1888, Joaquin Miller wrote, "Were I asked to put a finger on the one most favored spot to be found on the map of the world for rod and gun and restful camp, I would indicate the tributary waters of the Sacramento with Mount Shasta for a tent." (Both courtesy College of the Siskiyous Library.)

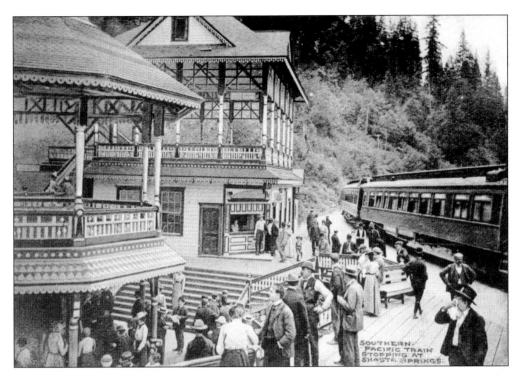

In 1889, Thomas Hall started the Mount Shasta Mineral Spring Company and began bottling the water and delivering it by rail to nine locations from Portland to Los Angeles. A pavilion was later built over the springs (above left). For those not staying at the resort, trains made 10-minute stops so passengers could get out and sample the water at no cost (below), although souvenir drinking cups were available for purchase. (Both courtesy College of the Siskiyous Library.)

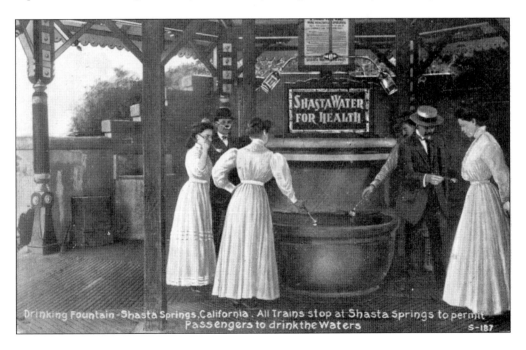

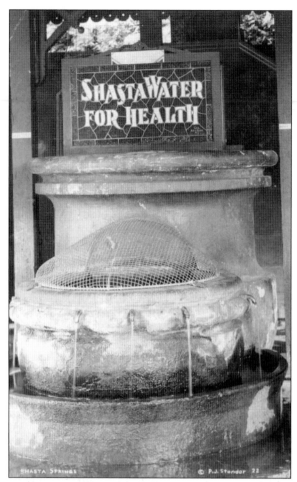

During the construction of the railroad to Sisson, the railroad crew, which had camped near Shasta Springs, had cemented in a drinking fountain (left). The *Mott Star* reported that the spring poured out 20 gallons a minute. The upper grounds of Shasta Springs were reached by an incline railway from the railroad station (below) or by a path up the canyon past the cold springs that rush down nearby. (Left, photograph by P. [Paul] J. Standar; both courtesy College of the Siskiyous Library.)

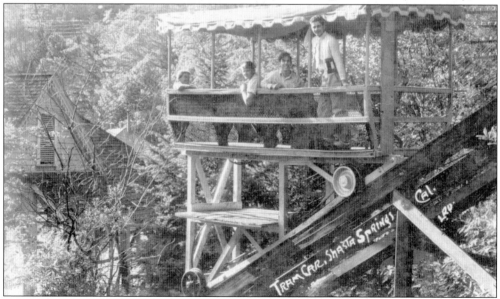

In 1891, a camp was established on a plateau 300 feet above Shasta Springs to house the resort's first guests. Fifty years before, a Native American village had occupied the site, and it had also been the campsite for the 2,000 railroad construction workers. Covered in oak, cedar, spruce, and pine, the site was located near the stage road. Later, cottages (above) would replace the camp and an elegant clubhouse was built (below). (Above, photograph by P. J. Standar; both courtesy College of the Siskiyous Library.)

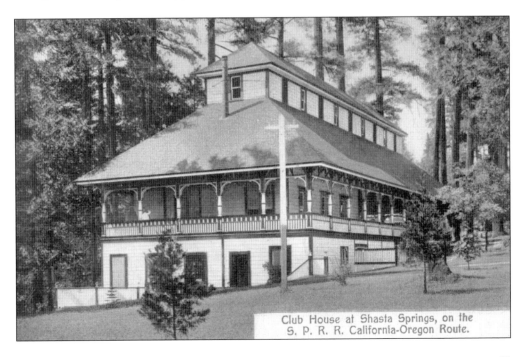

Club House at Shasta Springs, on the S. P. R. R. California-Oregon Route.

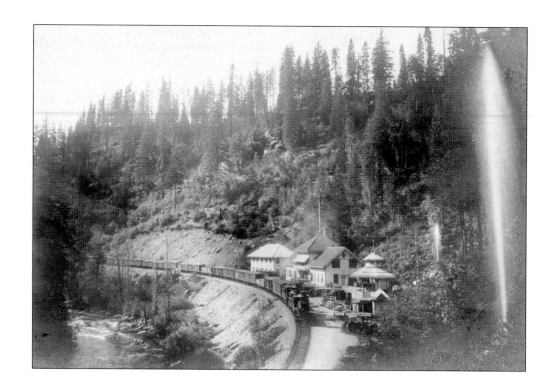

Two distinct seasons are photographed at the Shasta Springs Resort. As the train approaches the station on a sunny day (above), the geyser can be seen shooting up to the right. During winter, a rotary snowplow pushed by a steam locomotive is used to clear the tracks during a snowstorm. (Above, photograph by R. J. Waters; below, photograph by C. R. Miller; both courtesy College of the Siskiyous Library.)

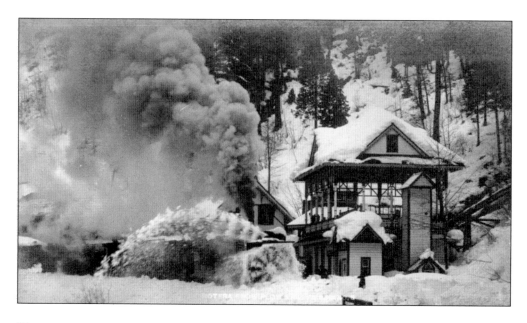

These visitors at right are relaxing near geyser and enjoying the sounds of the falls (below) at Shasta Springs. With the decline in rail travel in the 1920s, Shasta Springs eventually closed. In 1951, the St. Germain Foundation purchased the resort from the Shasta Water Company of Dunsmuir. The St. Germain Foundation was founded in the 1930s by Guy W. Ballard with its headquarters in Illinois. Because Mount Shasta holds a special spiritual significance for its members, a reading room, a church, and an amphitheater were built in the city of Mount Shasta where pageants and activities are held each year. (Below, photograph by P. J. Standar; both courtesy College of the Siskiyous Library.)

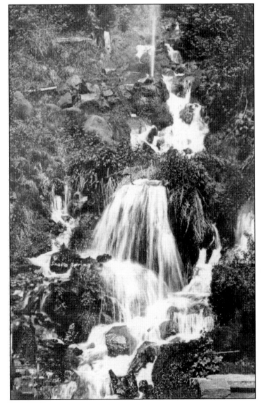

In 1887, while out on a hunting trip, John Ney (pictured at left) and Taylor Barr came upon mineral springs located about five miles south of Sisson. Originally called Stink Creek, Ney bought out Barr, changed the name to Ney Springs, and built a hotel that could accommodate 50 guests. In Sisson, Ney also owned a general store and saloon and ran the Berryvale Hotel and Restaurant with his wife, Catherine. (Courtesy Siskiyou County Museum.)

Faery Falls

Sutter Engrave
420 J Street
Sacramento

Guests at Ney Springs Hotel disembarked from a station at Cantara near the Sacramento River, and a carriage took them two miles to the resort. This 80-foot-high waterfall called Faery Falls was part of the resort property. Guests could also use a bathhouse and use the waters Ney was bottling for medicinal and beauty purposes. (Courtesy College of the Siskiyous Library.)

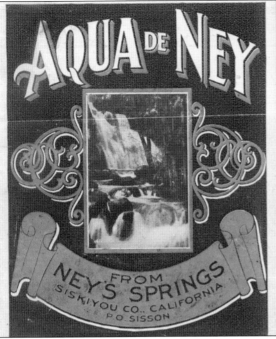

By the early 20th century, Ney Springs Hotel had become a popular health spa. Despite the odor, Ney's Aqua de Ney and Beauty Water were marketed and sold. When John Ney died in 1914, his wife, Catherine, continued to manage the hotel until her death in 1927. Their daughter Clara Ney kept it open as a summer resort until World War II. After vandalism destroyed the buildings, they were burned down by the fire department. Little remains of this once flourishing resort. The land is now owned by the U.S. Forest Service. (Both courtesy Sisson Museum.)

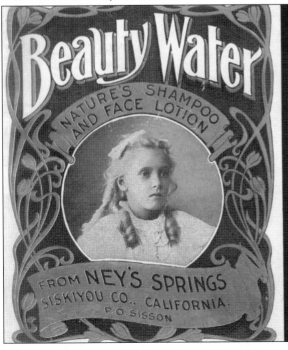

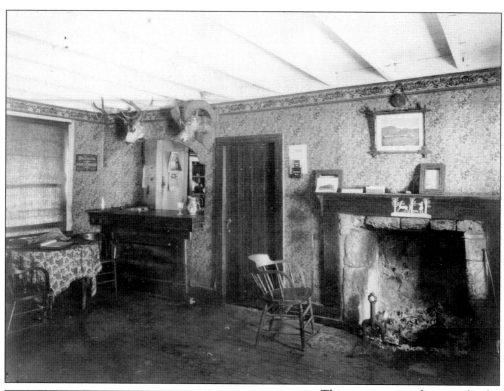

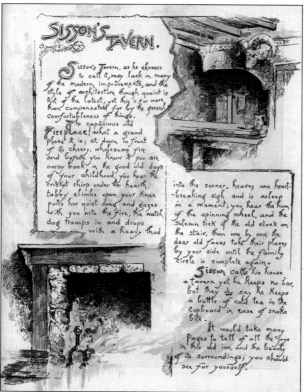

This rare interior photograph of Sisson's (above) was taken for a Southern Pacific Railroad travel booklet, *Shasta the Keystone of California Scenery*, written by E. McDonald Johnstone in 1887. The book was used to encourage tourists to visit the Mount Shasta area by rail on the newly built Shasta Route. Johnstone's warm remarks about a pleasurable visit to Sisson's are surrounded by his etchings (left), which replicate the interior photograph. (Photograph by H. C. [Howard Clinton] Tibbets; both courtesy College of the Siskiyous Library.)

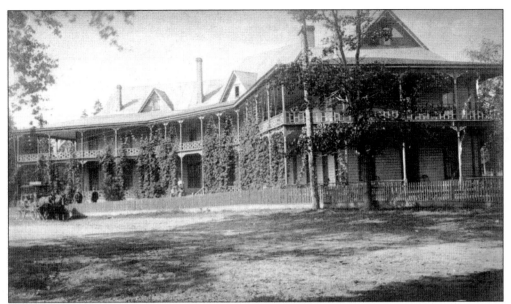

Double tragedy struck the Sisson family in 1893, the first in June when the historic hotel, and all its contents, was destroyed by fire caused by the explosion of a coal oil lamp. The second tragedy occurred five months later when Sisson, who had been ill for some time, passed away at the age of 67. G. W. Cooper of Yreka was hired by Lydia Sisson to design a new inn called Sisson's Tavern (above). Lydia Sisson continued to operate the hotel with help from her children. (Courtesy College of the Siskiyous Library.)

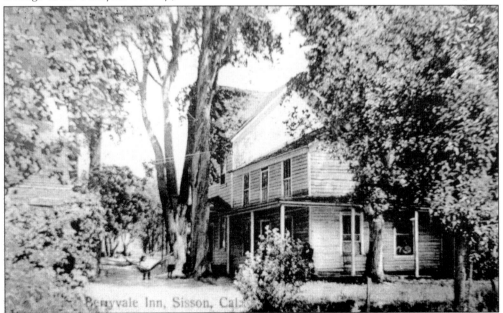

Berryvale's other well-known hotel, the Mount Shasta Hotel, had been leased to Jerome Fay and his partner in 1887 from Sophia Fellows. Upon her death in 1897, her grandson Henry Ream inherited the ranch and moved there with his family in 1902. He and his wife, Amelia (Kiefaber), ran a small summer resort in the old hotel, adding new rooms and renaming it the Berryvale Inn. (Courtesy Siskiyou County Museum.)

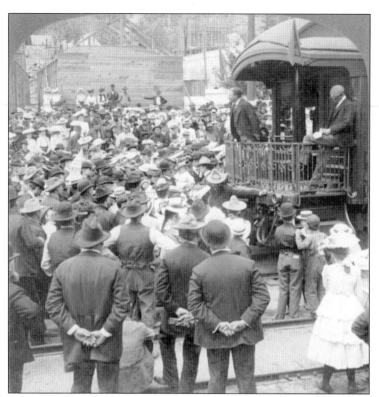

In May 1903, Pres. Theodore Roosevelt traveled through Northern California by train, making stops at the Southern Pacific depots in Dunsmuir, shown above, and Sisson. In Sisson, he made an eight-minute stop where, after a warm reception, he gave a short speech from the back of the railroad car. Roosevelt would later write, "I consider the evening twilight on Mount Shasta one of the grandest sights I have ever witnessed." In 1905, Roosevelt established the Shasta National Forest. This Southern Pacific advertisement of the Road of a Thousand Wonders (right) illustrates the breathtaking view passengers had of Mount Shasta as they traveled by train. (Both courtesy College of the Siskiyous Library.)

Six

THE GREAT OUTDOORS

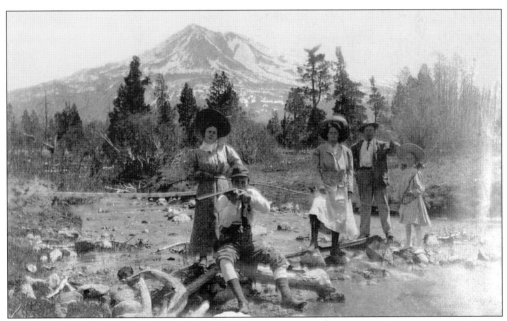

Because of Mount Shasta's natural setting and its variety of outdoor recreational activities, the area has been a magnet for tourists far and wide from the days of Sisson's friendly inn to the present. This early photograph of a group "sauntering about" a meadow is perhaps best described in an article written by John Muir in *Picturesque California*: "tourists are dropped at Sisson's, about 12 miles from the summit, whence at headquarters they radiate in every direction to the so-called 'points of interest;' sauntering about the flowery fringes of the Strawberry Meadows, bathing in the balm of woods, scrambling, fishing, hunting, riding about Castle Lake, the McCloud River, Soda Springs, Big Spring, deer pastures, and elsewhere." By the late 19th century, tourists of a higher economic status had also discovered Mount Shasta's beauty and began building summer homes where they hosted their out-of-town guests. Later skiing would also become a popular pastime with the development of a ski resort. (Courtesy Siskiyou County Museum.)

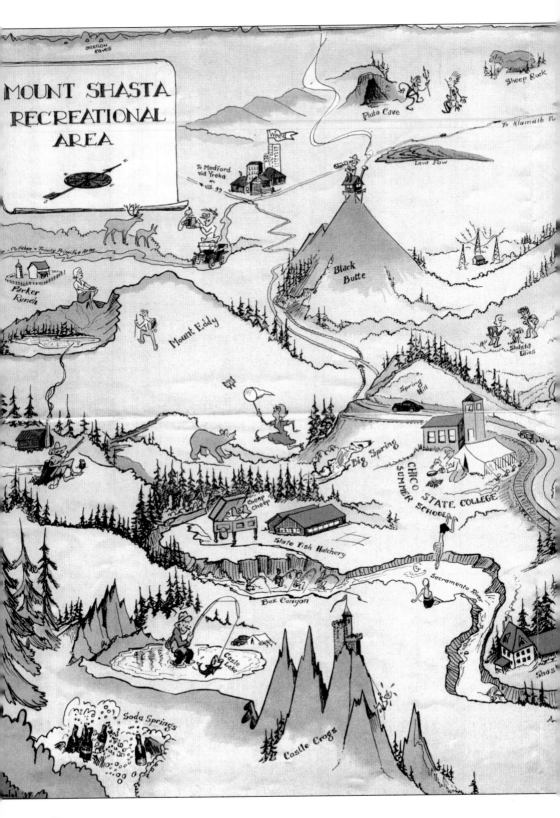

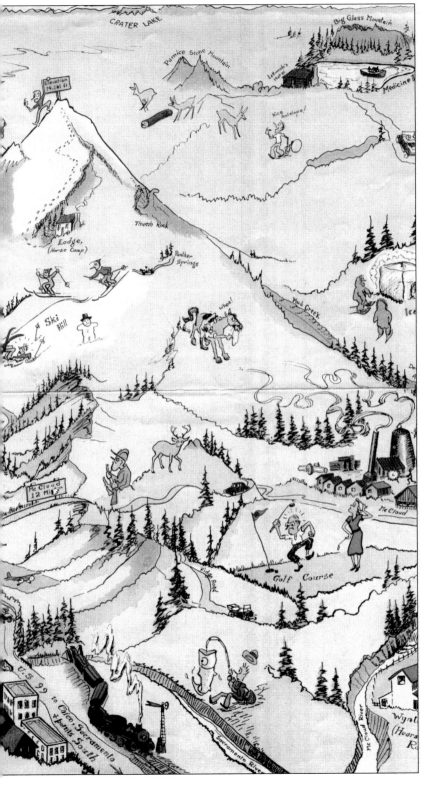

The Mount Shasta Recreational Area map was published by Chico State College in 1936 showing the location of its summer school in Mount Shasta and the recreational spots its students could enjoy around the area. Chico Normal School began its summer school in Sisson in 1919 after students had threatened not to attend classes at the Chico campus because of the extreme summer heat. The map shows a plethora of scenic spots that have been popular recreational destinations. (Courtesy California State University, Chico, Meriam Library, Special Collections.)

An afternoon outing in the Shasta-Trinity National Forest is captured in this photograph taken in May 1905. It may have been a day for gathering wildflowers or berry picking, two popular pastimes. Note the bucket in the center of the photograph and the young girl who looks like she just tasted something good. (Photograph by B. A. Coleman; courtesy Shasta-Trinity National Forest, Mount Shasta Ranger Station.)

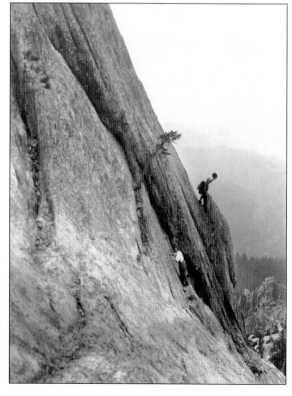

These rock climbers scaling Castle Crags make it look quite effortless as they pose on the edge of a narrow precipice in 1922. Castle Crags' highest peak rises to 5,000 feet, described by naturalist Edward Stuhl as a "most picturesque glacier-carved mass of pinkish-white granite." Castle Crags State Park was established in 1933. (Photograph by P. J. Standar, courtesy College of the Siskiyous Library.)

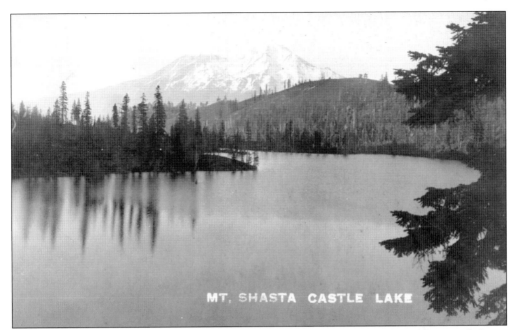

MT. SHASTA CASTLE LAKE

Located southwest of Sisson, a pristine alpine lake called Castle Lake (above) lies nestled in a granite bowl below Castle Crags. Visitors since the time of Sisson's have gone there to fish and swim in the summer and ice fish and ice skate in the winter. These men (below) are hiking up to Castle Lake, as it was accessible from Sisson on foot or by saddle and later by car. (Above, photograph by E. J. Lawless; both courtesy College of the Siskiyous Library.)

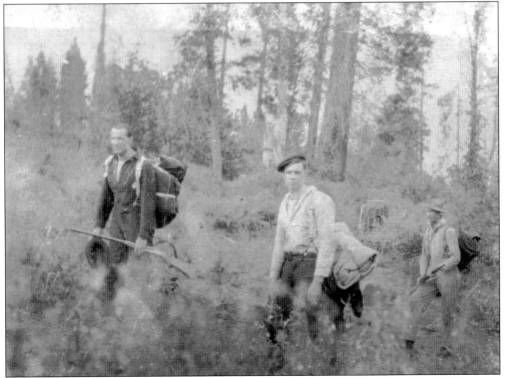

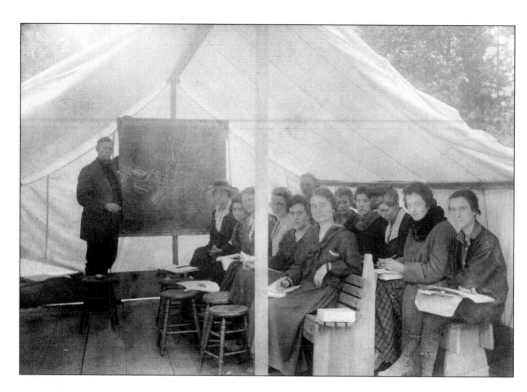

C. K. Studley is instructing a class in 1921 (above) at Chico State College's Mount Shasta Summer School, which was located on five acres of land that had been donated by the forest service (site of the current City Park in Mount Shasta). Classes were first held in tents with wooden floors and sides. This class in 1925 (below) was conducted *en plein aire*, taking advantage of Mount Shasta's pleasant weather. (Below, photograph by Emma Wilson and donated by John Nopel; both courtesy California State University, Chico Meriam Library, Special Collections.)

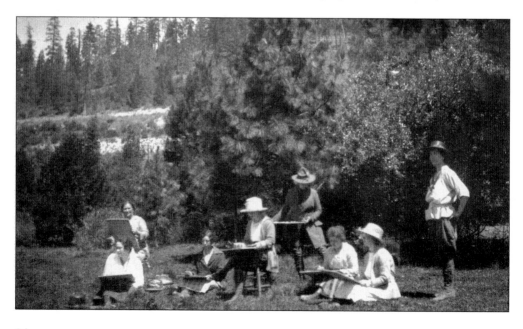

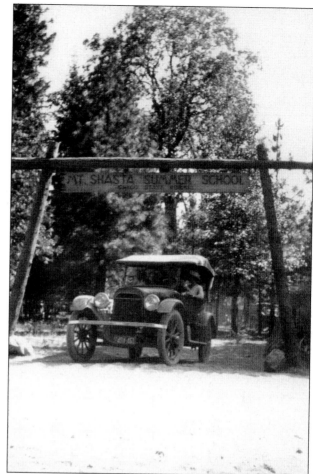

This car is passing through the entrance of the Mount Shasta Summer School (right). The school first used tents for lodging (below), but buildings would later be constructed for both classes and lodging. The buildings are still in use today. (Both photographs by Emma Wilson, donated by John Nopel, courtesy California State University, Chico Meriam Library, Special Collections.)

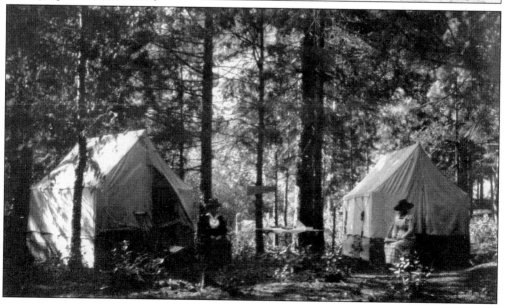

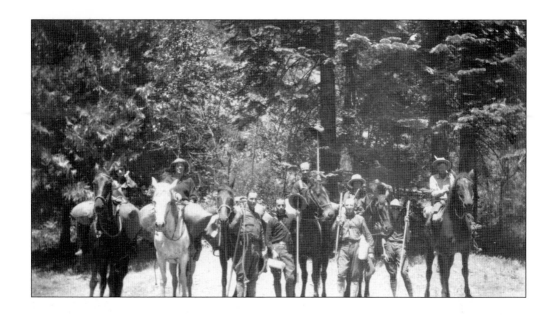

After morning classes, students at the Mount Shasta Summer School could spend time hiking, fishing, swimming, or mountaineering. These students are ready to head out to the mountains on horseback (above), while others are shown enjoying an afternoon of fishing. Chico closed the school during World War II because of a shortage of gas and rubber, which made school repairs expensive. (Both photographs by Emma Wilson, donated by John Nopel; courtesy California State University, Chico Meriam Library, Special Collections.)

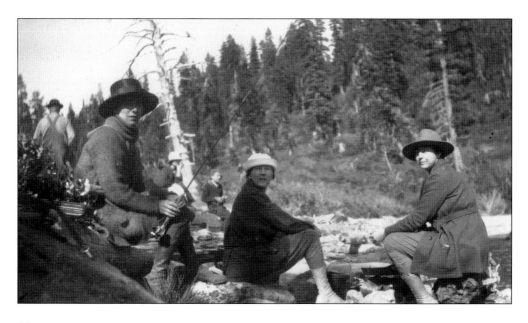

Located northwest of Mount Shasta, Sheep Rock rises to an elevation of 5,714 feet. Because of its milder conditions, it served as the winter pasture for the wild bighorn sheep that used to live on Mount Shasta. The sheep's demise has been attributed to the severe winter storm of 1889–1890. Travelers on the emigrant trails used it as a resting place. John Muir stopped there on his walk around the mountain, as did Edward Stuhl, who took this photograph during a trip with Helen Wheeler in September 1932. (Courtesy California State University, Chico, Meriam Library, Special Collections.)

Around the mountain, on the east side of Mount Shasta sits Medicine Lake, pictured in 1931. The lake is a small part of the summit caldera of the Medicine Lake Volcano, a very large shield volcano with a slope so gradual that it is hard to know you are standing on a volcano. (Courtesy College of the Siskiyous Library.)

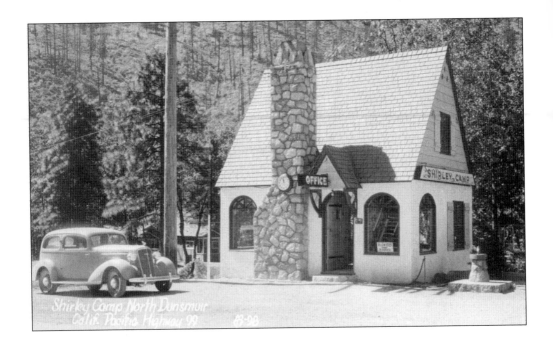

As train travel was replaced by the automobile, a new form of lodging replaced the resort. "Auto camps" sprang up along the new highways such as this one called Shirley Camp located on the Pacific Highway in North Dunsmuir. Traveling by automobile meant people could spend the night in different places, unlike the earlier resort era where extended stays in one location were the norm. This man looks perfectly contented (below), next to his cozy tent on a car camping trip in September 1925. (Courtesy College of the Siskiyous Library.)

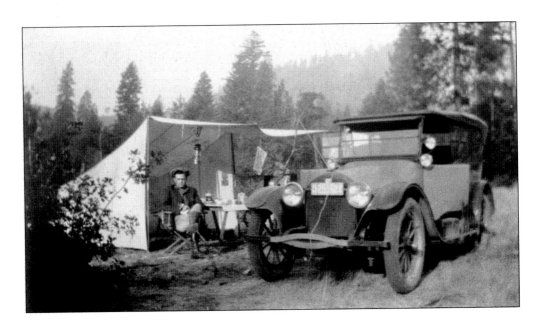

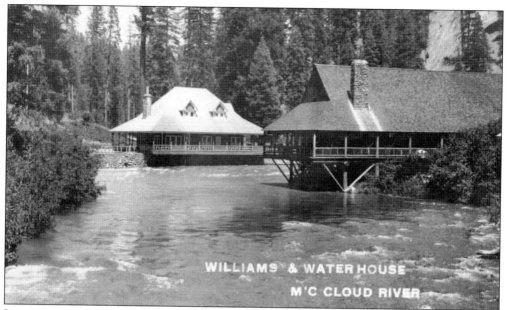

In contrast to traveling and camping by automobile, the wealthy found another way to recreate in the area by buying up unique properties, such as the old fishing resorts on the McCloud River, where they built summer homes. San Francisco plumbing firm owner Clarence Waterhouse purchased George McCloud's property on the McCloud River in 1890. It is pictured here in 1905 with the home of Thomas Williams, the Emeryville racetrack owner. (Photograph by C. R. Miller, courtesy College of the Siskiyous Library.)

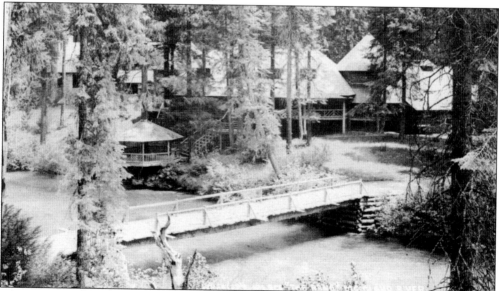

Lydia Sisson sold "the Bend" to San Francisco attorney Charles S. Wheeler in 1899. Willis Polk, supervising architect for the 1915 Panama Pacific International Exposition, designed his home featuring a "Fish Tower" with "piscatoribus sacrum" inscribed above the entrance. Two windows contained aquariums with McCloud River trout, while the main hall housed an 800-volume library and several hundred Native American baskets. (Photograph by C. R. Miller, courtesy College of the Siskiyous Library.)

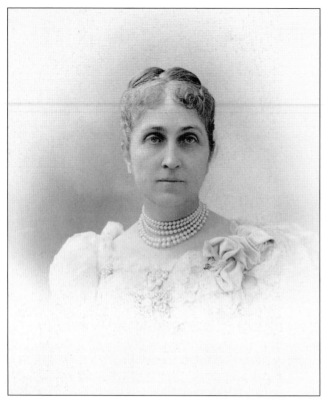

In 1900, Charles S. Wheeler invited his client Phoebe Apperson Hearst, pictured at left in 1898, to be his guest at the Bend. Enchanted by the area's natural beauty, she wanted to purchase some of his land to build a summer home, but he agreed only to lease it to her. Architect Bernard Maybeck designed a medieval-style structure, using native lava rock, with a three-story tower. Wyntoon (shown below) was completed in 1903. (Left, courtesy Siskiyou County Museum; below, courtesy College of the Siskiyou Library.)

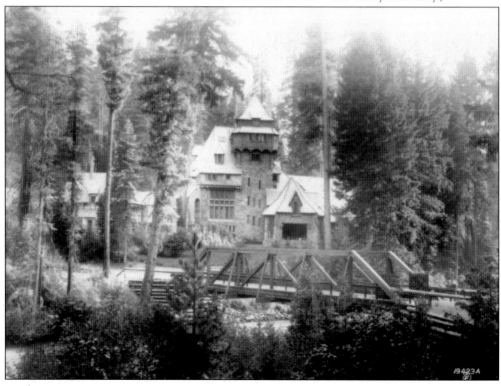

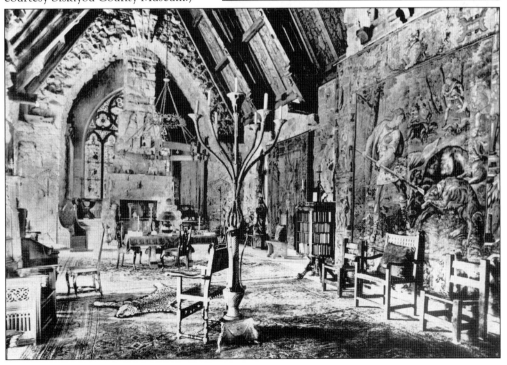

These two interior photographs of Wyntoon show the assembly hall where Phoebe Apperson Hearst entertained her guests. Above the fireplace, the initials P. A. H. and the date 1902 are inscribed. The room was decorated in a medieval style with Flemish tapestries covering the walls. For outdoor recreation, guests enjoyed tennis, archery, swimming, and horseback riding on over 75 miles of trails. (Both courtesy Siskiyou County Museum.)

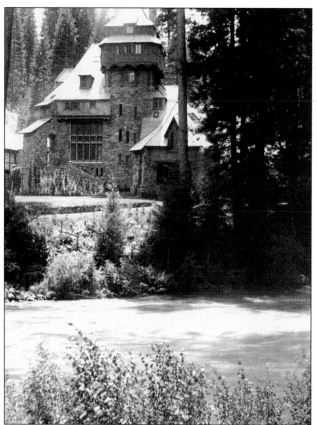

In 1929, William Randolph Hearst purchased Wyntoon from the Wheeler estate, shown at left in another view. Shortly after, a fire broke out, completely destroying the castle. Hearst hired Julia Morgan, the architect for Hearst Castle in San Simeon, to design a new home upstream on the Waterhouse property, which he had also acquired. Built along the McCloud River, a Bavarian village was created using names from fairy tales such as "the Cinderella cottage." The old Waterhouse place was remodeled and named River House. Hearst also acquired the Bend in 1934, tearing down the original Wheeler home (leaving one wing with its cornerstone: "The Bend—1899") and reconstructing it using the same black lava rock. The size of Hearst's estate was at one time estimated at 50,000 acres. (Both courtesy Siskiyou County Museum.)

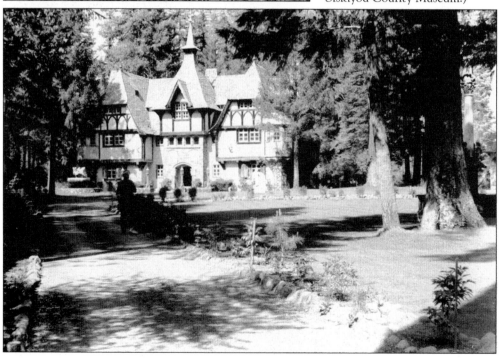

The development of winter sports in Mount Shasta began in 1925 when a group of local ski enthusiasts called the Mount Shasta Snowmen, under John M. Schuler's leadership, built a toboggan run located between the city of Mount Shasta and McCloud. In the 1930s, the group developed Snowman's Hill on the McCloud summit near the old run. State and regional ski meets were held there, and in 1947, a rope tow was added. (Both photographs by J. H. Eastman, courtesy College of the Siskiyous Library.)

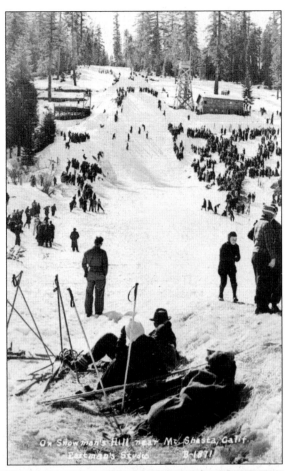

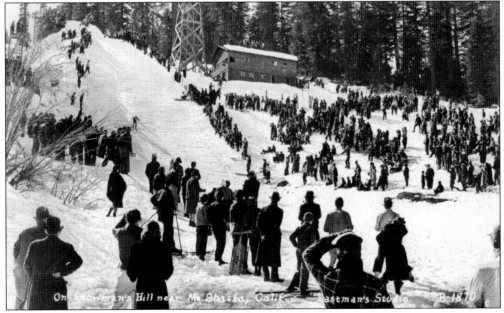

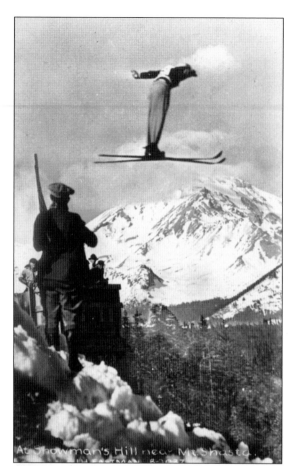

This spectacular jump (left) was made at Snowman's Hill where spectators came to watch these talented skiers. The snowplow below is making parking space at Snowman's Hill at the McCloud Summit. (Left, photograph by J. H. Eastman; both courtesy College of the Siskiyous Library.)

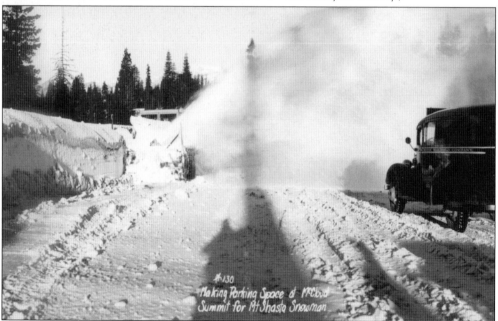

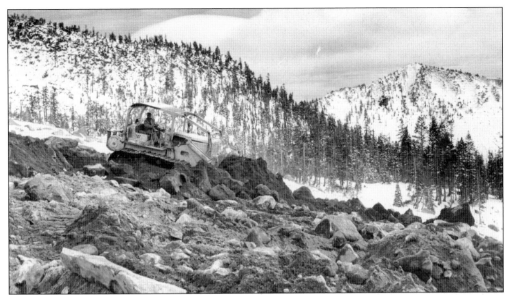

Arthur Rogers of Redding used his bulldozer during the construction of an extension of the Everitt Memorial Highway on the slope of Mount Shasta in 1957 or 1958 to serve a new ski resort, the Mount Shasta Ski Bowl. After forest supervisor John Everitt died in a major wildfire on the slopes of Mount Shasta in August 1934 near Bear Springs, the Mount Shasta Snowline Highway has been renamed the John Samuel Everitt Memorial Highway in his honor. (Courtesy College of the Siskiyous Library.)

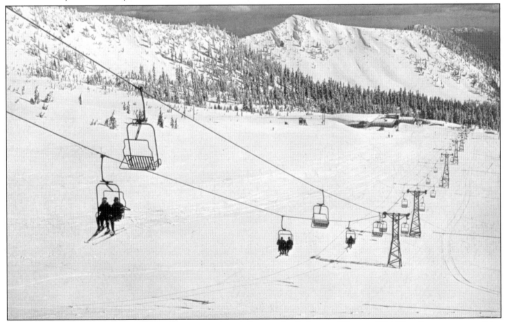

After many years of work by community members, the Mount Shasta Ski Bowl was opened in 1958. Located at the end of the Everitt Memorial Highway above Panther Meadows at an elevation of 7,800 feet, the resort had a large lodge and became popular with winter sports enthusiasts. Skiers enjoyed the stunning views from the chair lift, pictured here. (Courtesy College of the Siskiyous Library.)

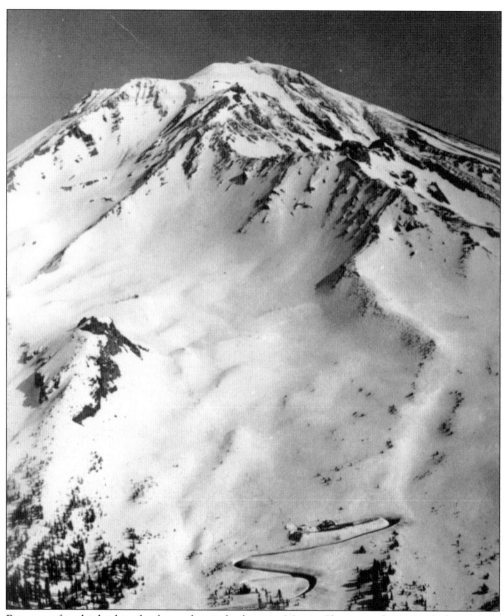

Because of its high altitude above the timberline on Mount Shasta, with its wind, deep snow, whiteouts, and fog, the Ski Bowl was forced to shut down at times. The resort and lifts can be seen at the bottom of this photograph with Mount Shasta's summit towering above. Despite financial losses, plans were still being made to expand the resort with a lift to the summit. When a fire destroyed the lodge in October 1971, the company reorganized and the resort was renamed Ski Shasta. In 1978, a major snowstorm resulted in a huge avalanche on Green Butte, which destroyed the chair lift. The resort closed at the end of the season and never reopened. While attempts to rebuild a resort near the same location failed, another resort, the Mount Shasta Ski Park, opened in 1985 at a different location and is a popular ski destination for both locals and tourists. (Courtesy College of the Siskiyous Library.)

Seven

MOUNT SHASTA IN THE 20TH CENTURY

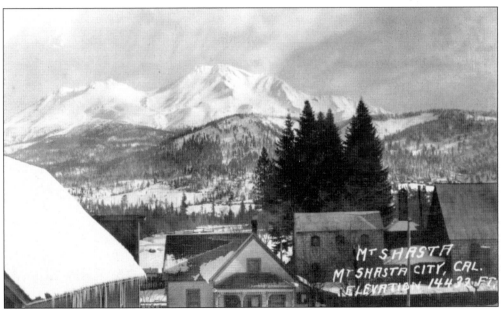

This photograph was taken from a second-story building in downtown Sisson looking east toward Chestnut Street and Mount Shasta. In 1912, the Sisson Promotion Society led by Merton J. Knox and Edward H. Kaupp sent a resolution to Pres. William Taft requesting that Mount Shasta "with suitable land around it together with what little timber yet remains be set aside as a park." For Sisson, the new century ushered in more devastating fires, which destroyed the downtown and local landmarks. With the advent of the automobile, the old wagon roads were improved, resulting in the decline in railway travel and the end of the railroad resorts. In 1922, the citizens of Sisson voted to change the name of the town to Mount Shasta, a controversial vote that was written about in the *San Francisco Chronicle*. The post office finally made the change official on June 4, 1924. (Courtesy College of the Siskiyous Library.)

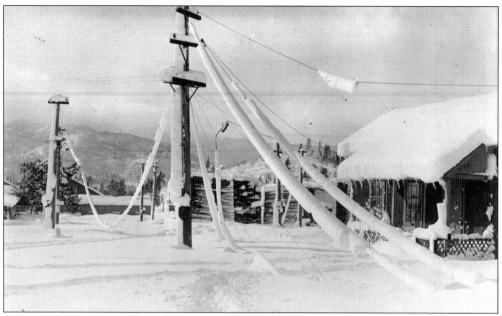

While this may not be one of Sisson's biggest snowfalls, it is a lovely scene of downtown Sisson, taken by Preston Fidler after a snowstorm in 1907. (Courtesy College of the Siskiyous Library.)

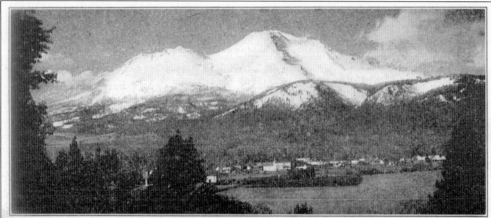

Sisson Tavern, Mount Shasta in the Background

SISSON TAVERN
Sisson, Shasta County California

An ideal place for the vacationist. Boating, fishing and hunting on private reserve. Nine-hole golf links. Tents and cottages for rent. Children's playground. Guide and outfitting for climb up Mount Shasta. The Sisson Tavern Company has made arrangements to run automobiles to Shasta daily for the accommodation of guests.

For further information and reservation, address

Q. H. BERRY, *Manager*

The landmark Sisson Tavern was finally sold by the Sisson family in 1910. Sisson's daughter, Belle Sisson Maguire, states that the original hotel was usually referred to only as Sisson's while the rebuilt hotel was called Sisson Tavern. This advertisement for the tavern by the new owners appeared in *Sunset Magazine* highlighting its many amenities. (Courtesy College of the Siskiyous Library.)

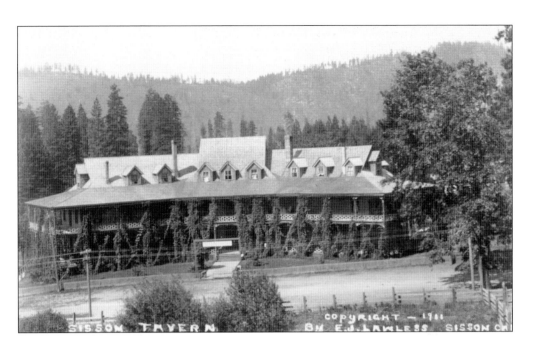

Tragedy struck the Sisson Tavern once again on June 10, 1916, when it caught fire and burned down. The above photograph shows the tavern as it looked before the fire. Below is a photograph of the tavern going up in flames, destroying this once beautiful structure. The property changed ownership again, but the tavern was never rebuilt. The site of Sisson Tavern, which held so much history, is now a beautiful meadow along Old Stage Road next to the Mount Shasta Fish Hatchery and Sisson Museum. (Above, photograph by E. J. Lawless, courtesy College of the Siskiyous Library; below, courtesy Siskiyou County Museum.)

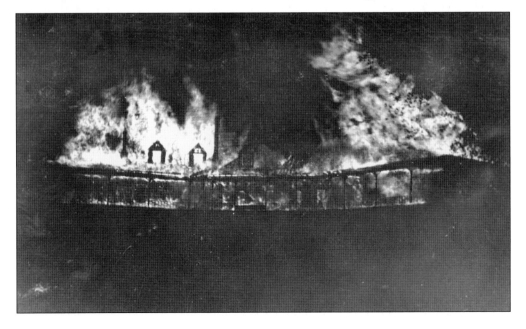

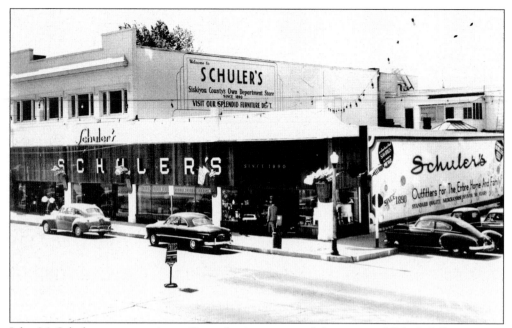

John M. Schuler was a prominent Sisson businessmen and the owner of Schuler's Department Store, pictured above in the 1930s. On Sunday, June 26, 1904, a batch of candy left on the stove at Hansen's Confectionary boiled over and burned down most of the downtown district on both sides of the street and in the block south. It was reported that most citizens were watching a baseball game and could not make it in time to put out the fire. After the fire, Siskiyou Lumber and Mercantile sold their lots to Schuler-Knox, where Schuler built his store. (Courtesy Siskiyou County Museum.)

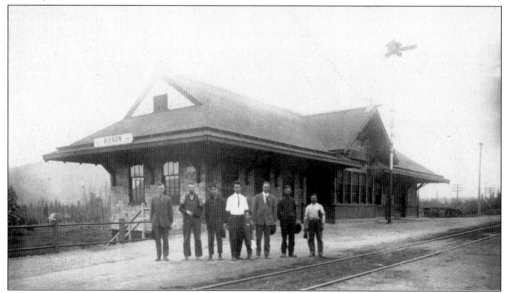

The original Sisson Depot Hotel burned down on July 18, 1907, and was replaced in 1914 by a smaller depot, above, located at the same place on the northwest corner of Walnut and Alma Streets. Once passenger service in the town was discontinued by the railroad, the building was sold and moved to a site just outside the city limits. (Courtesy Sisson Museum.)

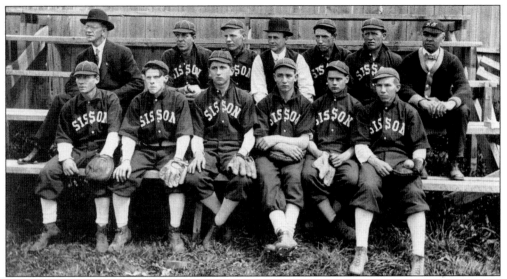

The Sisson baseball team (about 1909) probably held their games in a baseball field located on Alma Street behind the old passenger depot (now the Mount Shasta Ranger Station). Walter C. Spann, whose father published the weekly *Sisson Headlight* from 1904 to 1910, wrote, "In those days there were three projects which all small towns tried to maintain: a baseball team, a brass band, and a weekly newspaper." Below, Sisson's brass band is, from left to right, (first row) Dr. Frank Fuller, J. Summers, C. Summers, Frederick Sullaway, F. Vannoy, F. Nickerson, and Albert Pipes; (middle row) John Spann, Charles Klein, J. D. Graham, L. Phillips, T. Rose, and N. Mapes; (third row) W. Randolph, C. Rose, J. Naves, Charles Gooch, A. Graham, H. B. Cartmell, and E. Hale. (Above, photograph by A. J. Joslin; both courtesy Sisson Museum.)

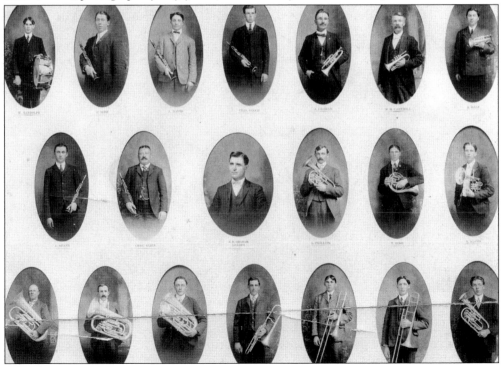

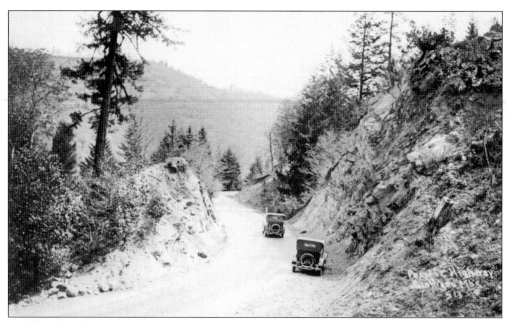

With the invention of the automobile, early drivers had to navigate dirt or gravel roads before pavement was installed. These automobiles are slowly making their way over the Siskiyou Mountains near the Oregon-California border. Improvements to the Siskiyou Pass were first made in 1915. (Courtesy College of the Siskiyous Library.)

This timetable carried the schedule for the Pickwick Stages for the Shasta Route from Portland to San Francisco, shown with Mount Shasta in the background The founding coach line of Greyhound, Pickwick was also involved in hotels, broadcasting, and air transportation. Its first passenger service bus line was started in 1911 in San Diego and eventually expanded to serve 20 cities and the countries of Mexico and Guatemala. (Courtesy College of the Siskiyous Library.)

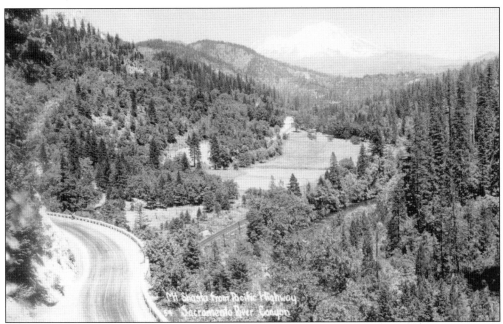

In the early days of the automobile, it took a day to get from Shasta Springs to Redding and three days from San Francisco during the summer. The road could not be driven during the winter. In the early 1910s, a decision was made to have the Pacific Highway follow the Sacramento River Canyon route, which was finally completed in 1932. Glimpses of Mount Shasta could be seen while driving along the highway's circuitous route (above). As the road begins the climb toward Mount Shasta, the bridge (below) crosses the Sacramento River at Dunsmuir. Constructed in 1916, it was built at the same location as the bridge built by Ross McCloud over 150 years ago at Upper Soda Springs, which lies below. The Olelbes (meaning "God") Tauhindauli Park and Trail is now being developed there. (Both courtesy College of the Siskiyous Library.)

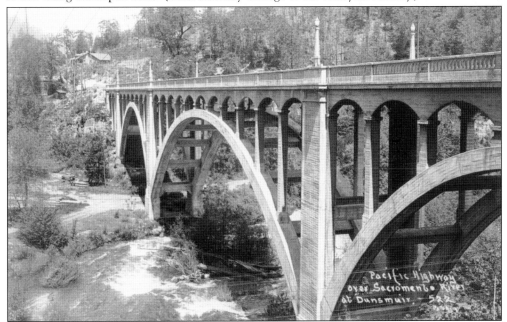

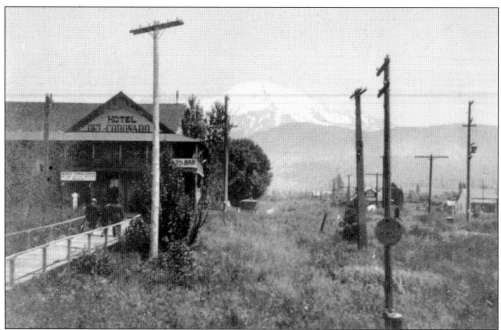

The Del Coronado Hotel, pictured in 1913 with Crocker Plaza (right), used a boardwalk from the street to the hotel to keep their guests out of the mud. This block was destroyed by fire in 1915, including the hotel and A. E. Doney's building next door. Edward Stuhl made his first visit to Mount Shasta in 1917 and noted that 11 saloons were in operation in Sisson, along with Mugler's Brewery and Saloon. When the downtown burned in 1896, Mugler had rebuilt with non-flammable materials, which helped stop another fire that burned Whiskey Row in 1917. (Courtesy Perry Sims.)

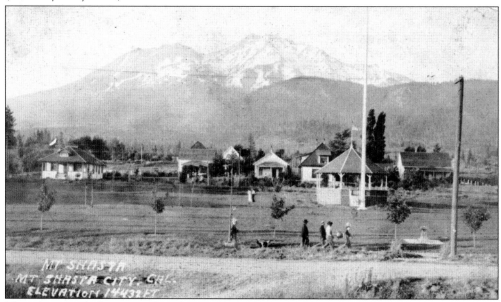

This photograph shows Crocker Plaza or Sisson Park after the gazebo and fountain were put in, probably in the 1920s. Behind the plaza is a row of houses on Chestnut Street, some of which are still standing today. (Courtesy Perry Sims.)

The Eagles Junior Band and conductor Charles Graham (center) are shown on the second floor of the city hall (now the police department). It served as a high school in 1916 until a permanent one was built on Pine Street. From left to right are (first row) unidentified, James Caswell, Voyle Richardson (?), Lawson "Rube" Davenport, Russell Gregory, Perry Sheldon, Harold Lawless, Wilbur Kaupp, Jack Caswell, and Leonard Bickel; (second row) Floyd Bell, Lloyd Landis (?), Albert "Dutch" Mugler, Peter Bell, Merritt Sheldon, Peter Miller, Frank Davis, "Happy" Richardson, Harry Douglas, Frederick "Ping" Davis, William Rupp, Russell Winchicomb, and William Reid. (Courtesy Sisson Museum.)

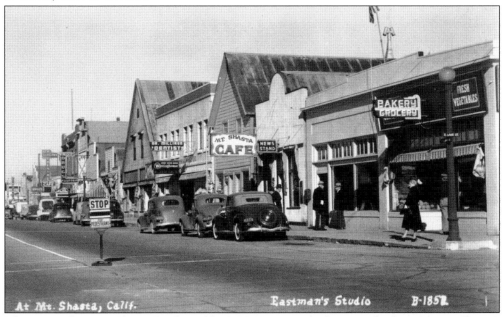

This view of Mount Shasta Boulevard by J. H. Eastman, looking north along Mount Shasta's main street, was probably taken in the 1930s. Sisson's last major downtown fire occurred in 1917. Heading north, the Pacific Highway left Mount Shasta Boulevard (formerly Walnut Street) at an intersection and followed Chestnut Street to the right, rejoining Mount Shasta Boulevard at the north end of town. (Courtesy College of the Siskiyous Library.)

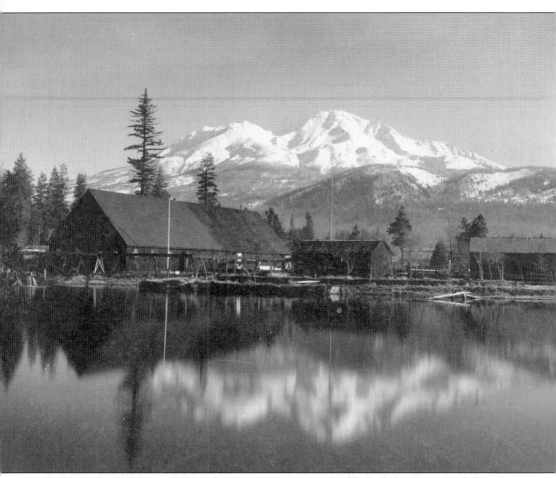

In 1888, the California Fish and Game Commission established the Sisson Fish Hatchery on Justin Sisson's land on Big Springs Creek for the purpose of propagating salmon (the land was purchased from him in 1892). Trout were later reared in the hatchery's ponds. This photograph of the pond and hatchery was taken by Herbert A. Hale in 1899. In 1916, the hatchery's name was changed to the Mount Shasta Fish Hatchery, now the oldest working hatchery in California. (Courtesy College of the Siskiyous Library.)

In 1909, the old fish hatchery building was torn down and a new one erected, shown above with the hatchery's crew. It now houses the Sisson Museum. Harold Shott and Curt Fowler are seen strapping milk containers onto mules (below), which were used to transport the fish to high mountain lakes. This practice continued until 1946 when it was discovered that airplanes could be used to drop the fish into the lakes with good precision and without injury to the fish! (Both courtesy Siskiyou County Museum.)

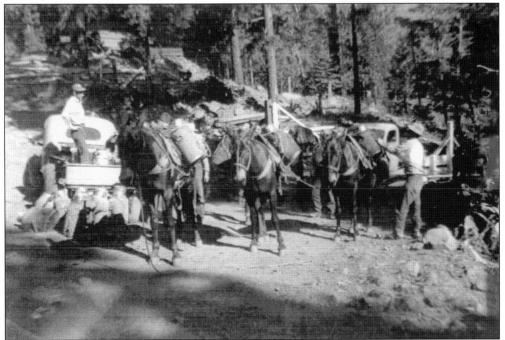

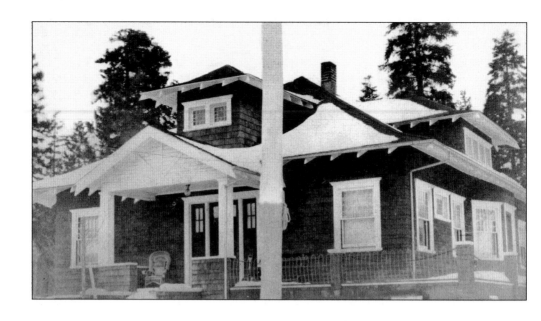

In about 1910, San Francisco entrepreneur Zack Abrams bought the Stewart property, consisting of 266 acres, for use as a summer home. The Stewart family had operated a sawmill north of Sisson since 1893. The winter after Abrams's purchase, the large home on the property burned down. A smaller one was built to replace it, pictured above. Three small lakes were also located there: Ram Lake, planted with fingerling trout each year; Green Lake, later opened to the public for swimming and boating; and Lake Elaine. In the winter, ice was cut from Green and Elaine and delivered to Sisson. On the Fourth of July, the Abrams family participated in the annual parade. They strung lights across one of the lakes and decorated the area with red, white, and blue bunting. "Abram's Lake" was photographed below by Burhl L. Harwood around the 1920s. (Above, courtesy Siskiyou County Museum; below, courtesy College of the Siskiyous Library.)

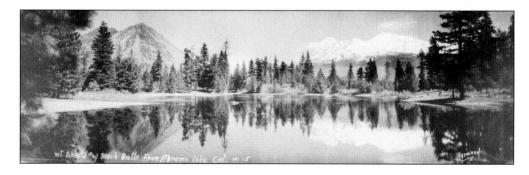

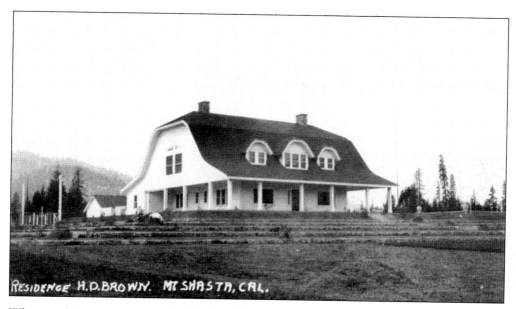

RESIDENCE H.D.BROWN. MT SHASTA, CAL.

When wealthy racehorse breeder H. (Harold) D. "Curly" Brown paid a visit to his friend Zack Abrams at his summer home, he became enchanted with Mount Shasta. In 1918, he bought 1,577 acres on what is now W. A. Barr Road and named it the Brownshasta Ranch. It consisted of a grand home, shown above, guest cottages, tennis courts, a swimming pool, sunken gardens, orchards, a stocked lake, and the north fork of the Sacramento River. He also built a large barn for his "Shasta Thoroughbreds" which included his horse Shasta Gold. On the Fourth of July, Brown began the tradition of shooting off fireworks from his lake, still a tradition today at nearby Lake Siskiyou. Brown was the leader of the campaign to change the town's name. A sign was erected next to the Brown Building, pictured below on December 29, 1931, with an overturned produce truck in the background. (Above, courtesy College of the Siskiyous Library; below, courtesy Siskiyou County Museum.)

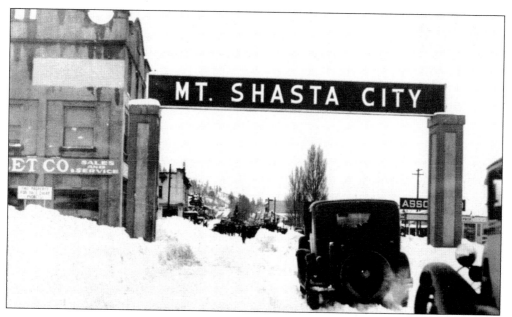

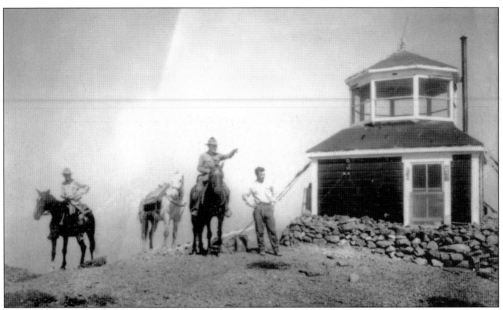

The Shasta National Forest was created by Pres. Theodore Roosevelt in 1905. Its first headquarters was located in the Schuler building. At one time, the forest service had 23 manned lookouts operating on high peaks and even on the tops of trees. These photographs were taken in 1914 of the Mount Eddy Lookout, the earliest lookout structure. It was built on Mount Eddy west of Sisson at a 9,000-foot elevation, from which thousands of acres of forestland could be viewed. In the photograph above, Earl "Dutch" Sullaway is standing. The other men are unidentified. Most of these lookouts have now been abandoned or destroyed. (Both photographs by W. S. Climb, courtesy Shasta-Trinity National Forest, Mount Shasta Ranger Station.)

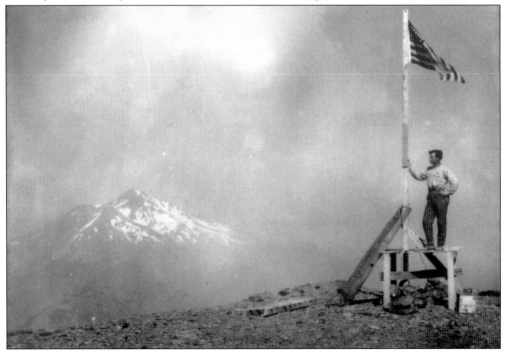

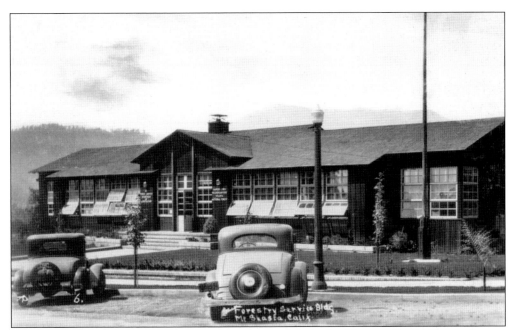

The Shasta National Forest office moved from the Schuler building to Castle Street, then to the Brown Building, and finally to a site on East Alma, pictured in 1936. After joining with the Trinity National Forest in 1954, the headquarters of the newly formed Shasta-Trinity National Forest moved to Redding. This building now houses the Mount Shasta Ranger Station. (Courtesy College of the Siskiyous Library.)

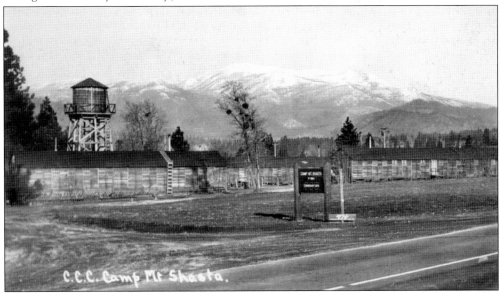

The Civilian Conservation Corps' Camp F-394 or "Camp Shasta" (above) was located five miles south of the railroad station near the old town site of Mott. A smaller "spike" camp was located south of the city of Mount Shasta. The corps assisted the forest service in various projects, including the construction of forest service lookouts and fire suppression during the 1930s. Different companies were stationed at the camp until October 1941 when Camp Shasta was closed. (Courtesy College of the Siskiyous Library.)

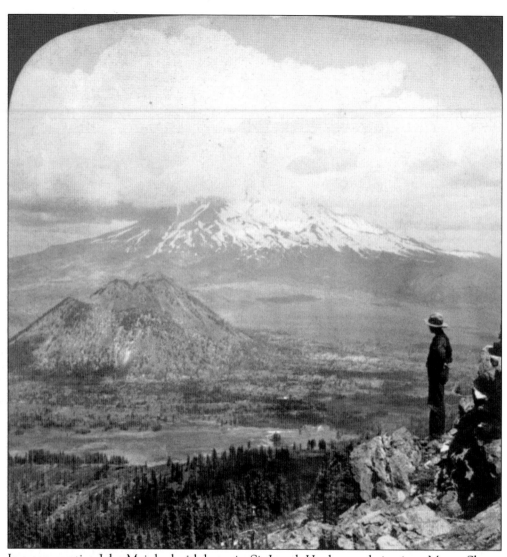

In a conversation John Muir had with botanist Sir Joseph Hooker on their trip to Mount Shasta in 1877, they "talked of trees," and Hooker, who had traveled through all the great forests of the world, "admitted that in grandeur, variety, and beauty, no forest on the globe rivaled the great coniferous forests of my much beloved Shasta." In 1888, Muir made a proposal for the creation of a national park—"Mount Shasta is a fresh unspoiled wilderness, accessible and available for travelers of every kind and degree. Would it not be a fine thing to set it apart like the Yellowstone and Yosemite as a National Park for the welfare and benefit of all mankind, preserving its fountains and forests and all its glad life in primeval beauty? Very little of the region can ever be more valuable for any other use—certainly not for gold nor for grain. No private right or interest need suffer and thousands yet unborn would come from far and near and bless the country for its wise and benevolent forethought." (Courtesy College of the Siskiyous Library.)

Having lunch with this group at the Sierra Club Alpine Lodge on July 15, 1956, would have been a real treat for anyone interested in the flora, geology, or history of Mount Shasta. These preeminent scholars are, from left to right, botanist William Bridge Cooke, *The Flora of Mount Shasta* author; naturalist/artist Edward Stuhl; Arthur Eichorn, *The Mt. Shasta Story* author; Robert and Betsy Cogburn; and J. Harold "Harry" Watkins, after whom the Watkins Glacier was named. (Courtesy California State University, Chico, Meriam Library, Special Collections.)

This delicate wildflower, the Shasta lily (*lilium washintonianum*), painted by Edward Stuhl, usually grows within reach of snow and can be found in the fields east of town below Mount Shasta. During his lifetime, Stuhl painted over 200 life-sized watercolors of Mount Shasta's wildflowers and, like John Muir before him, devoted many years studying the mountain and promoting its preservation. Stuhl died in February 1984. That same year, the Mount Shasta Wilderness was established as part of the National Wilderness Preservation System. (Courtesy College of the Siskiyous Library.)

BIBLIOGRAPHY

Brooks, Donna Kohn, ed. *The Siskiyou Pioneer Vol. 5 No. 4*. Yreka, CA: Siskiyou County Historical Society, 1981.

Eichorn, Arthur T. *The Mount Shasta Story*. Mount Shasta, CA: Mount Shasta Herald, 1957, 1987.

Jellison, Ellen. "A History of Upton, Siskiyou County, California." U.S. Department of Agriculture. Shasta-Trinity National Forest, Mount Shasta Ranger District, 1988.

Latour, Ira H., ed. *Silver Shadows: A Directory and History, Early Photography in Chico and Twelve Counties of Northern California*. Chico, CA: Chico Museum Association, 1993.

Miesse, William C. *Mount Shasta: An Annotated Bibliography*. Weed, CA: College of the Siskiyous, 1993.

———. *Mount Shasta Fact Sheet*. Weed, CA: College of the Siskiyous Library, 2005.

Miller, Joaquin. *Life Amongst the Modocs Unwritten History*. Berkeley, CA: Heydey Books/Orion Press, 1996.

Muir, John, ed. *West of the Rocky Mountains*. Philadelphia, PA: Running Press, 1976.

Park, Howard M. *Old Time Resorts About Mount Shasta*. Mount Shasta, CA: Sisson Museum, 1990.

Pollock, Hazel and Eleanor Brown. *The Siskiyou Pioneer Vol. 4 No. 3*. Yreka, CA: Siskiyou County Historical Society, 1970.

Sammons, E. C., ed. *Mazama A Record of Mountaineering in the Pacific Northwest*. Portland, OR: Mazamas, 1915.

Schrader, George and Isabel. *The Siskiyou Pioneer Vol. 2 No. 2*. Yreka, CA: Siskiyou County Historical Society, 1952.

Signor, John R. and Stephen Cutting. "Stations and Sidings." Dunsmuir, CA: Southern Pacific Archives, 1999.

Stuhl, Edward. *Mount Shasta Journal, 1917–1923*. Chico, CA: Association of California Records and Research: 1989.

Zanger, Michael. *Mt. Shasta: History, Legend and Lore*. Berkeley, CA: Celestial Arts, 1992.

RESOURCES

College of the Siskiyous Library
800 College Avenue
Weed, CA 96094
530-938-5331
www.siskiyous.edu/library

Mount Shasta Fact Sheet
www.siskiyous.edu/library/shasta/factsheet

Mount Shasta: An Annotated Bibliography
www.siskiyous.edu/shasta/bib/index.htm

Jefferson Economic Development Institute
403 Berry Street—P.O. Box 1586
Mount Shasta, CA 96067
530-926-6670
www.e-jedi.org
(Project funded in part by the Stewardship Fund of Far Northern California that provides visitors, residents, and businesses with positive opportunities to care for the natural, historical, and small-town cultural environments they love, visit, and enjoy. For more information about the fund, contact JEDI.)

Meriam Library, Special Collections
California State University, Chico
Chico, CA 95929-0295
530-898-6342
www.csuchico.edu/lbib/spc/iepages/home.html

Siskiyou County Museum
910 South Main Street
Yreka, CA 96097
530-842-3836
www.co.siskiyou.ca.us/museum/

Sisson Museum
1 North Old Stage Road
Mount Shasta, CA 96067
530-926-5508
www.mountshastasissonmuseum.org

ACROSS AMERICA, PEOPLE ARE DISCOVERING SOMETHING WONDERFUL. *THEIR HERITAGE.*

Arcadia Publishing is the leading local history publisher in the United States. With more than 4,000 titles in print and hundreds of new titles released every year, Arcadia has extensive specialized experience chronicling the history of communities and celebrating America's hidden stories, bringing to life the people, places, and events from the past. To discover the history of other communities across the nation, please visit:

www.arcadiapublishing.com

Customized search tools allow you to find regional history books about the town where you grew up, the cities where your friends and family live, the town where your parents met, or even that retirement spot you've been dreaming about.